Green Porno

A Book and Short Films by
Isabella Rossellini

harperstudio
An Imprint of HarperCollins Publishers

HarperCollins books may be purchased for educational, business, or sales promotional use. For information please write: Special Markets Department, HarperCollins Publishers, 10 East 53rd Street, New York, NY 10022.

For more information about this book or other books from HarperStudio, go to www.theharperstudio.com.

FIRST EDITION

Designed by Base

Library of Congress Cataloging-in-Publication Data is available upon request.

ISBN 978-0-06-179106-2

09 10 11 12 13 IM 10 9 8 7 6 5 4 3 2 1

Creative Team

When I envisioned *Green Porno* I had a specific look in mind. A number of talented friends helped me realize it. In fact they are so talented that they enhanced my vision. I am grateful to the following people for their enthusiastic collaboration:

Photography
Jody Shapiro

Lighting
Sam Levy

Costume and Set Design
Andy Byers and Rick Gilbert

Scientific Consultant
Claudio Campagna

Acknowledgments

I'd like to thank my lawyer, Bob Levine, who first thought *Green Porno* should be a book; Julia Cheiffetz and Bob Miller at HarperStudio for making it happen; and Yoon Seok Yoo and Huma Mody at Base Design for the final layout.

Contents

If I were an Anglerfish...

Bon Appé-tit! Anchovy

Bon Appé-tit! Squid

The Dan-gling Organ

Why Vagina

What is Green Porno?

Before I explain the origins of the book you hold in your hands, let me first say something about storytelling and what it means to me. I think visually, without words, perhaps because I come from a family with deep roots in the cinema (my mom is actress Ingrid Bergman and my father is filmmaker Roberto Rossellini), or perhaps because I grew up speaking multiple languages; no one language is truly mine. I always felt more comfortable modeling than acting, for example, because modeling is like being a silent movie star.

When Robert Redford, founder of Sundance, had the idea of short environmental films for the Internet, I knew it was a unique opportunity. I particularly love short silent films (George Méliès, Charlie Chaplin, Buster Keaton), and the idea that this classic format could be adapted to the Internet where shorts are so popular was appealing. I also knew if I didn't muster the chutzpah to make my writing and directorial debut in my late fifties, I probably never would. Laura Michaelchyshyn, my friend and executive at Sundance, suggested the films be a bit flashy. To me the word *flashy* translated into sex. I've always been interested in

animal behavior, and I certainly know a lot of people who are interested in sex. So, here you have the three elements that make the core concept of *Green Porno*: short stories, animals, and sex.

In each of the films I imagine myself as a particular animal and I make love as that animal would. Each film is scientifically accurate; nature is infinitely scandalous! The first animals I portrayed are the ones that live in my garden—the bee, the earthworm, the snail—and in my home: the spider, the fly.

When we set out to make these little films we thought they might strike a chord, but we had no idea over four million people would take an interest. Suddenly I found myself talking about *Green Porno* on the *David Letterman Show*. Who knew. Given the groundswell of interest in the first series, I was able to reach out to people in the scientific community to create a second set of films. The second *Green Porno* series, *Marine Animals*, has more of an overt environmental message and features the wonderful biologist Claudio Campagna.

I cut meat out of my diet a few years ago when I learned about the harmful effects of antibiotics and excessive hormones, but believed fish was a healthy choice. After working with Claudio, I lost my appetite for fish too.

Now, I'm sure you are wondering: "How did these unusual short films turn into a book?"

I believe a story can live in many different forms. In the case of *Green Porno*, I wanted the audience to be able to choose between the big screen, the mobile phone, or, in this case, a book and DVD. There is so much talk about the death of cinema or the death of the book. My hope is that storytelling will exist in all forms and utilize all technology that is available.

I hope *Green Porno* will give you two emotions. I hope it will make you laugh and will make you say, "Oh, I didn't know that about animals." By discovering the diversity, the mysteries, and the greatness of the animal kingdom, I also hope you'll fall in love with it and protect it.

— Isabella Rossellini

Bon Appé-tit!
Shrimp

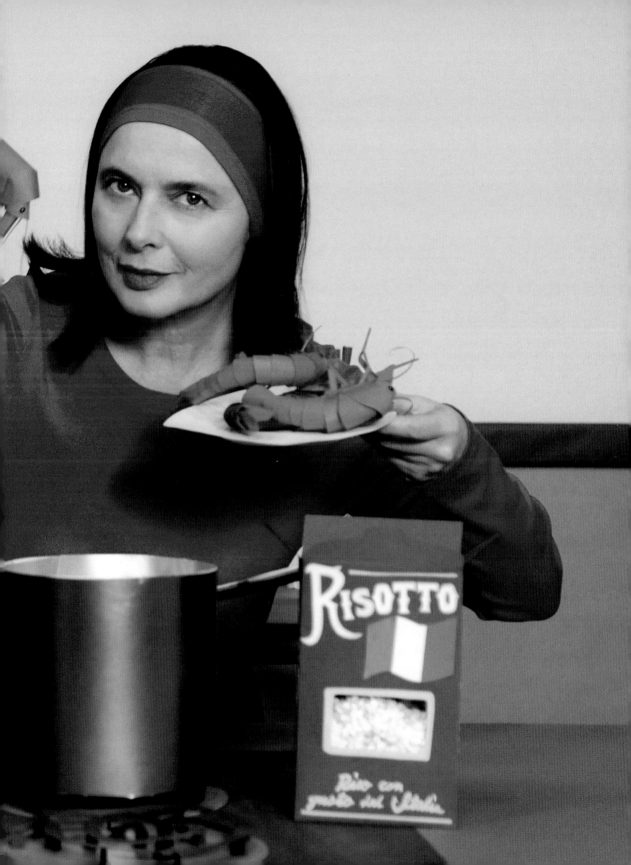

If I were a shrimp

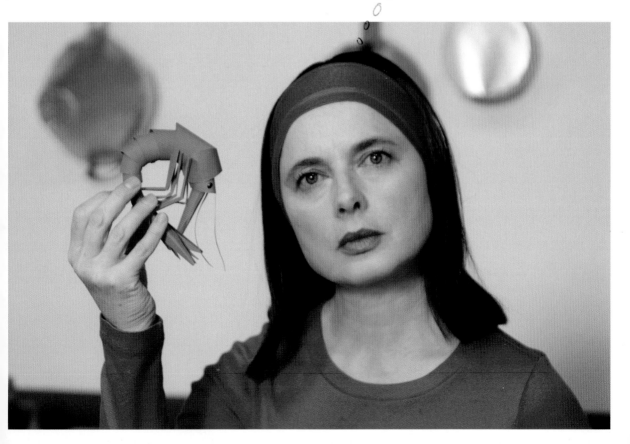

When little I would be **male**

But when fully grown I would change sex into a female

My armor-like skin is too tight
I would have to undress
I would have to molt

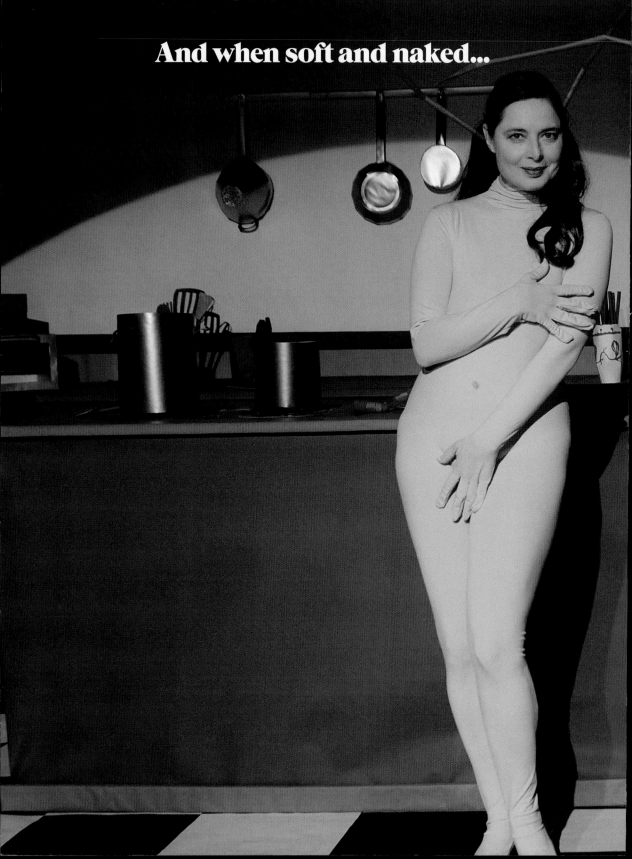

And when soft and naked...

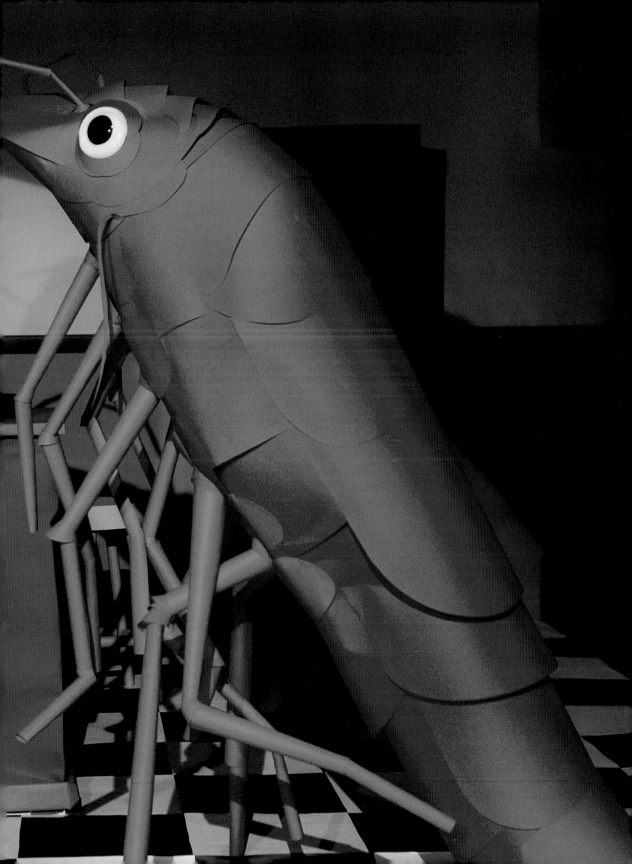

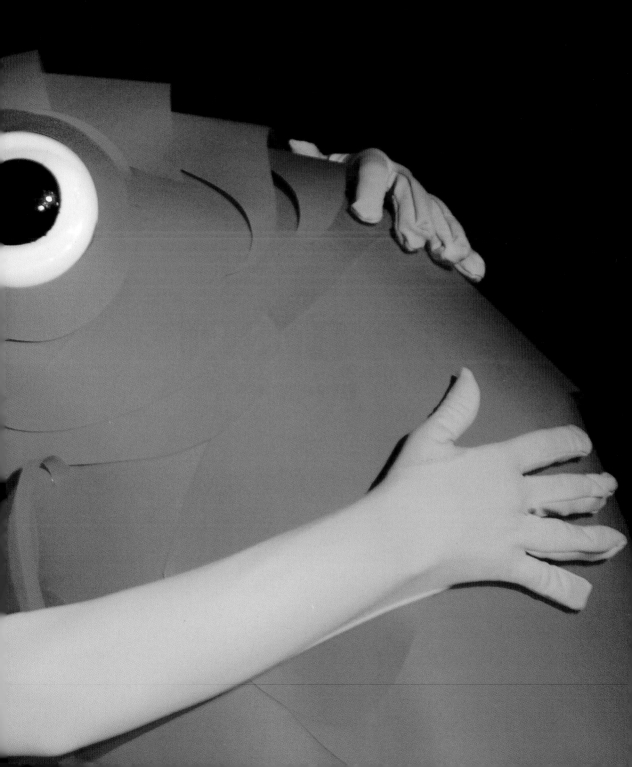

...I would **mate**

I would
protect
my eggs

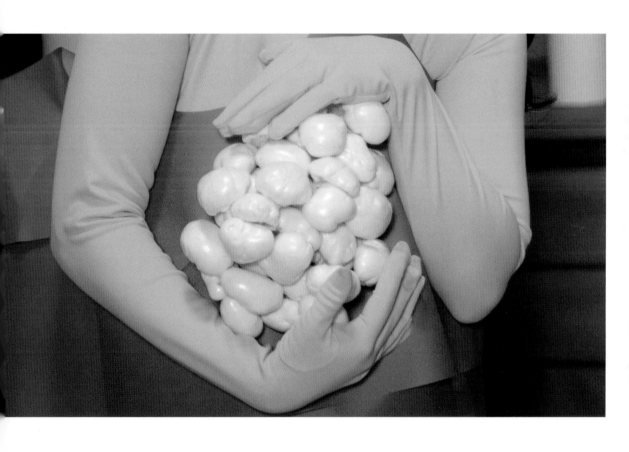

hhhh...

Nets catch us by the millions

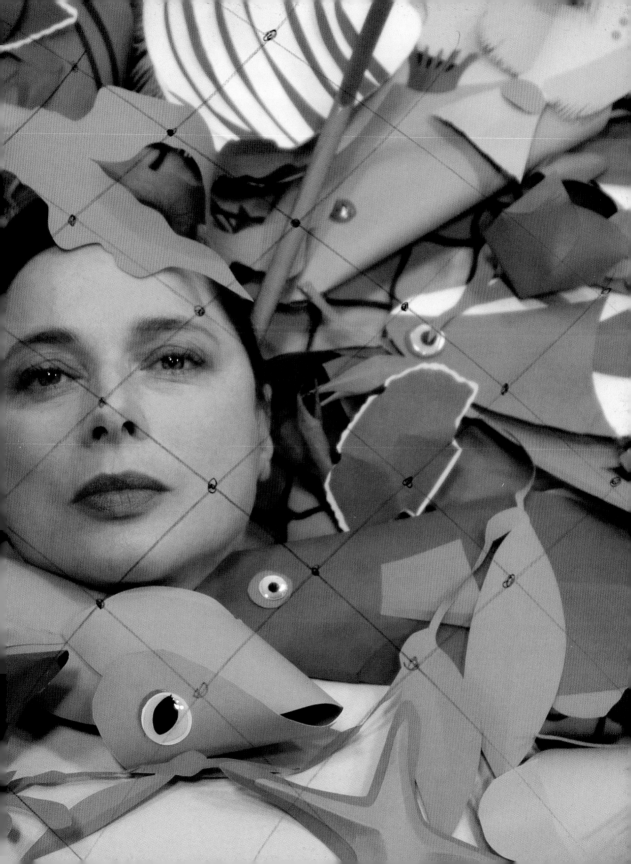

For every
one
shrimp caught
ten
other lives are lost

These lost lives
are called

bycatch

BYCATCH Certain types of commercial fishing methods are responsible for most bycatch. Trawling and dredging destroy sea floor habitats and catch everything in a ship's path. Long-line fishing and drift nets can stretch and suspend up to fifty miles across the ocean, scooping up anything bigger than the holes in the nets. Every day the total discard of bycatch is nearly 19,000 tons. This is the equivalent in weight to 4,000 adult elephants.

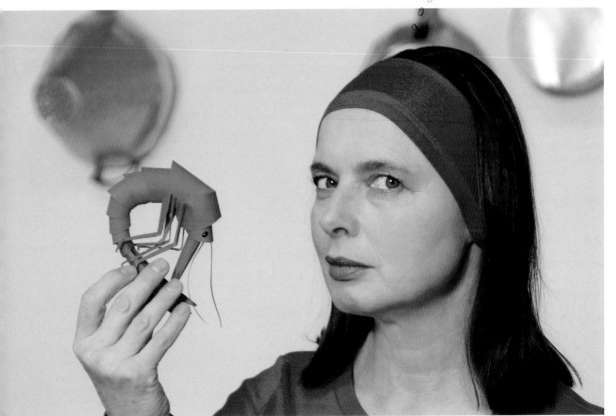

If I were a Barnacle...

As a baby barnacle
I would be called a larva

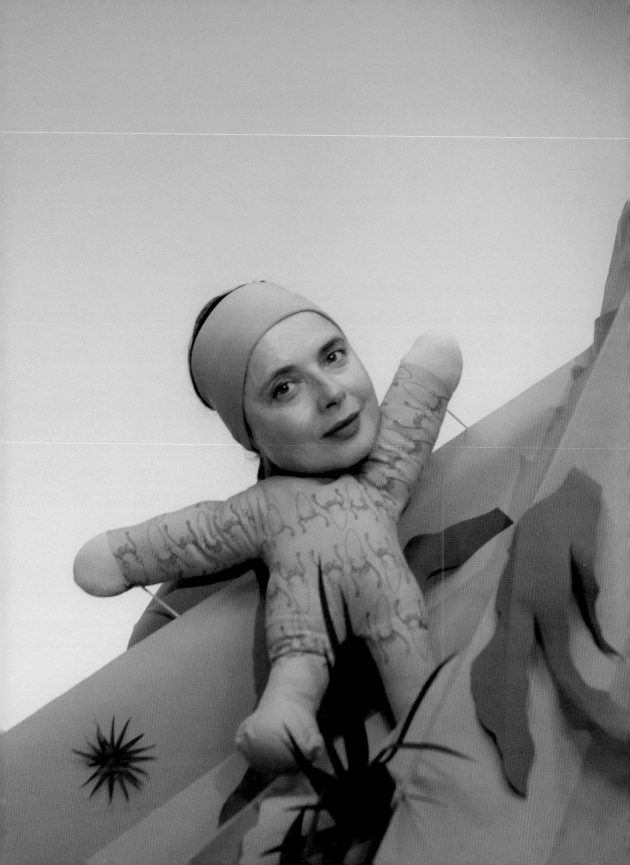

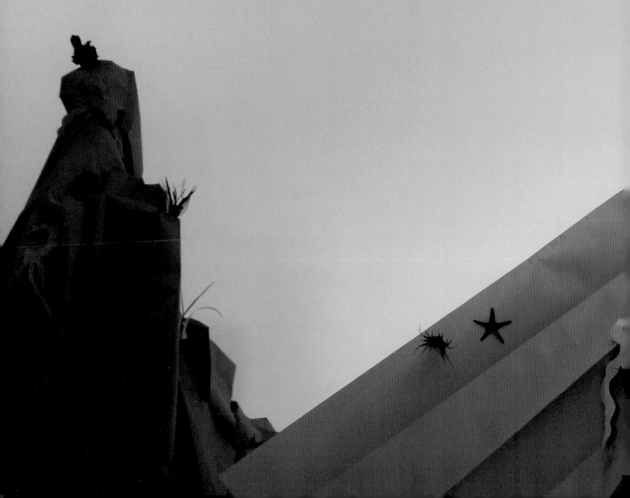

I would climb up
a sexually mature female

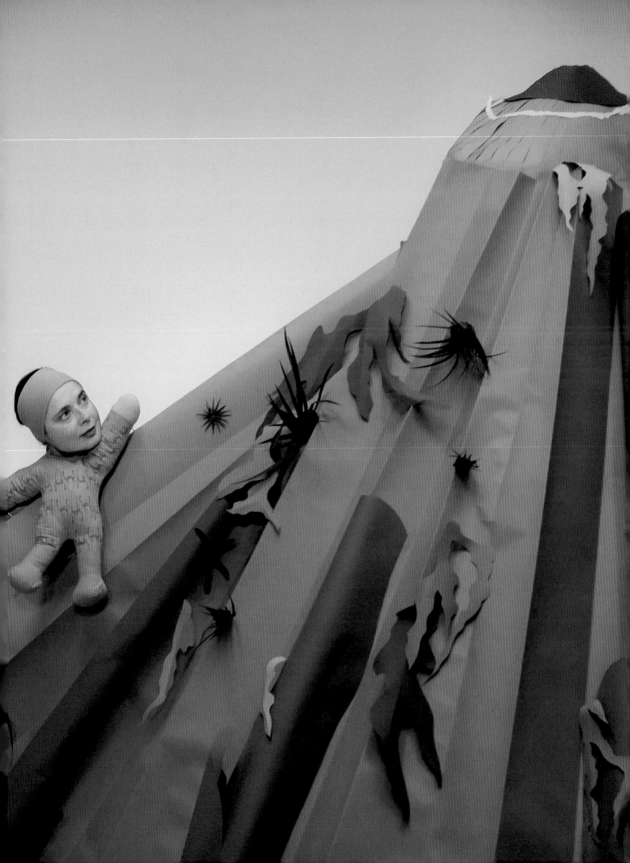

And inside her I would degenerate into a **sexual organ**

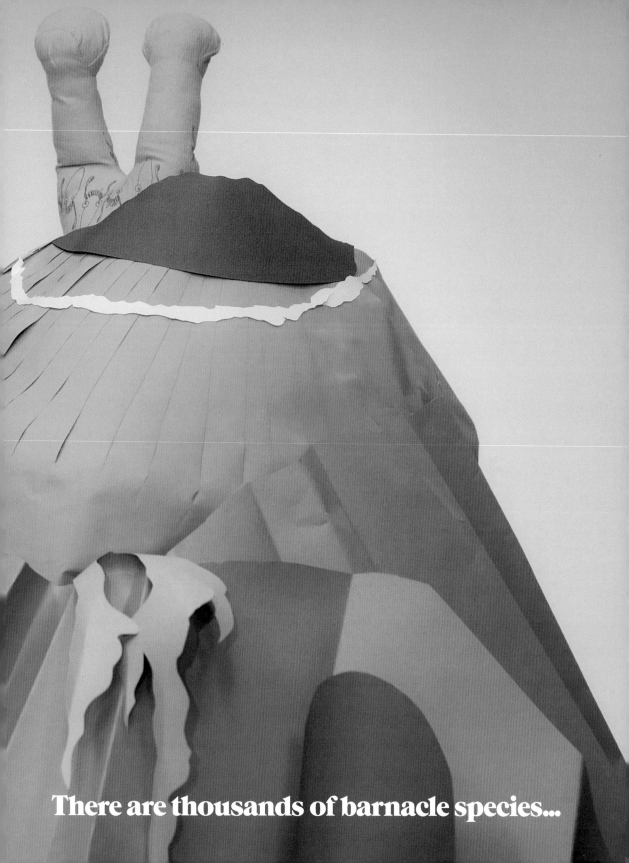

There are thousands of barnacle species...

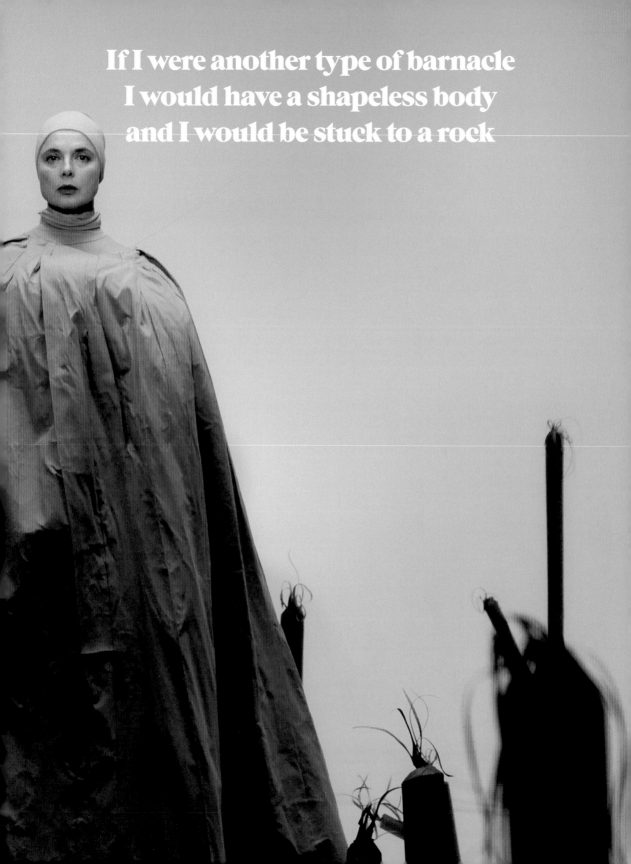

If I were another type of barnacle
I would have a shapeless body
and I would be stuck to a rock

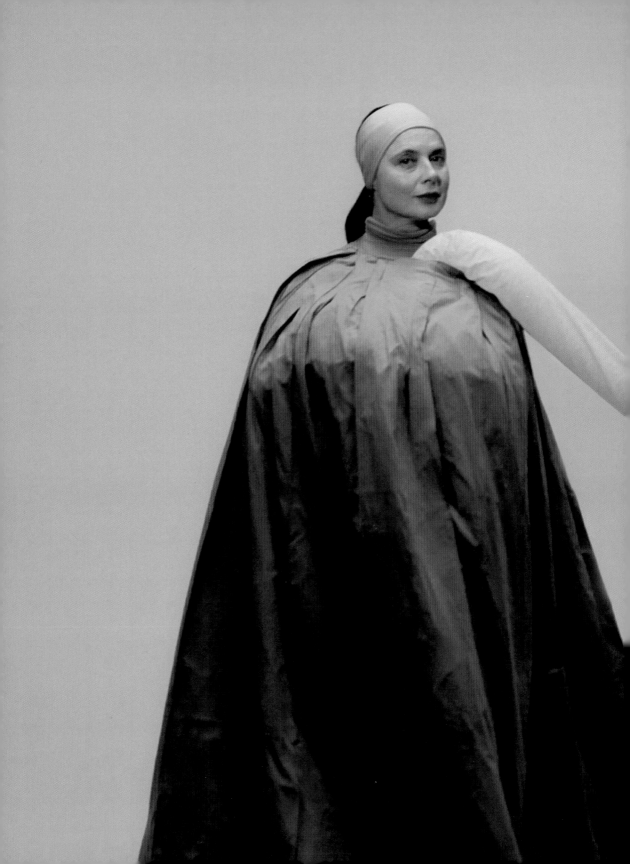

I would have to develop
a **long long** penis...

...to reach inside a female barnacle

If I were a Limpet...

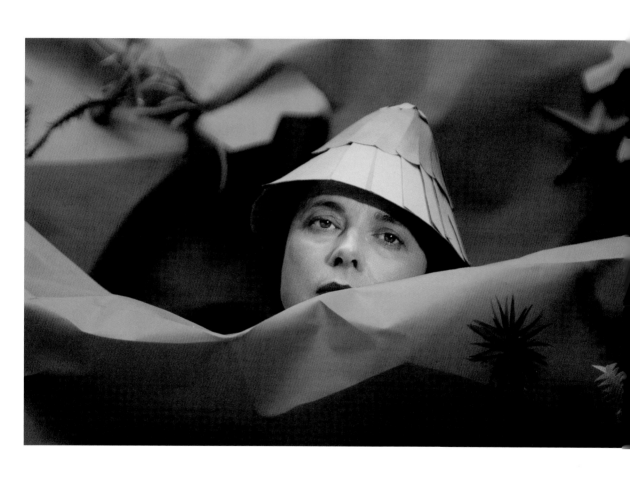

I would use a rock
to protect my flesh

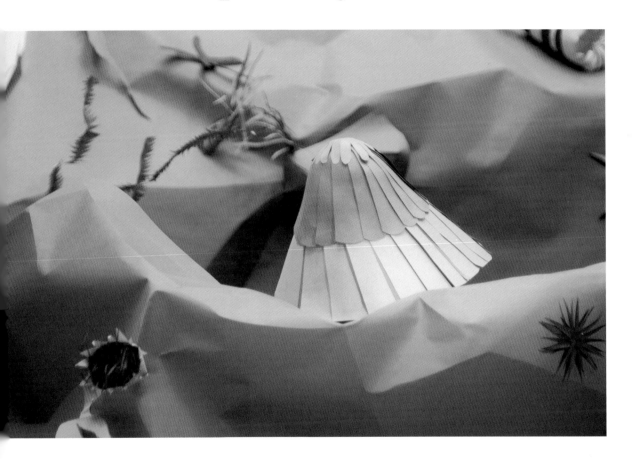

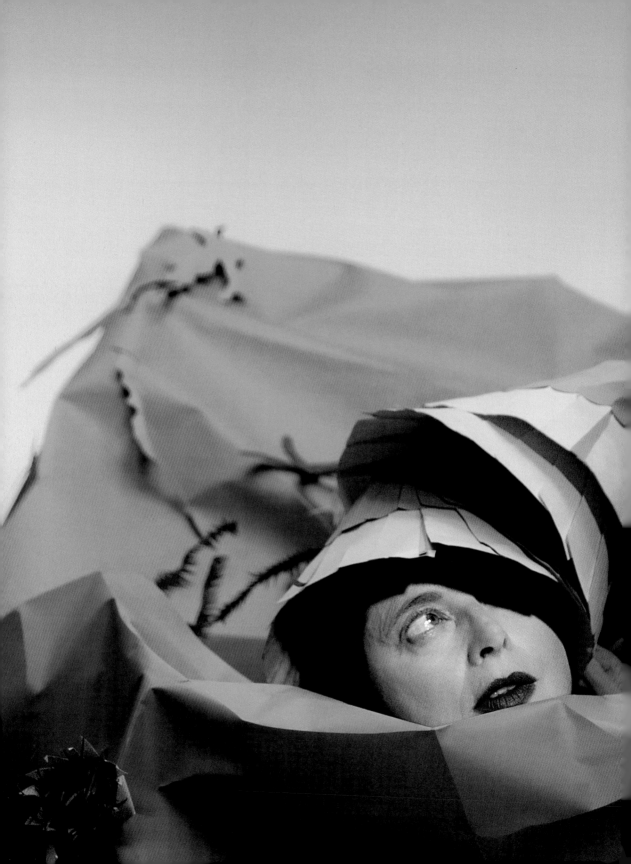

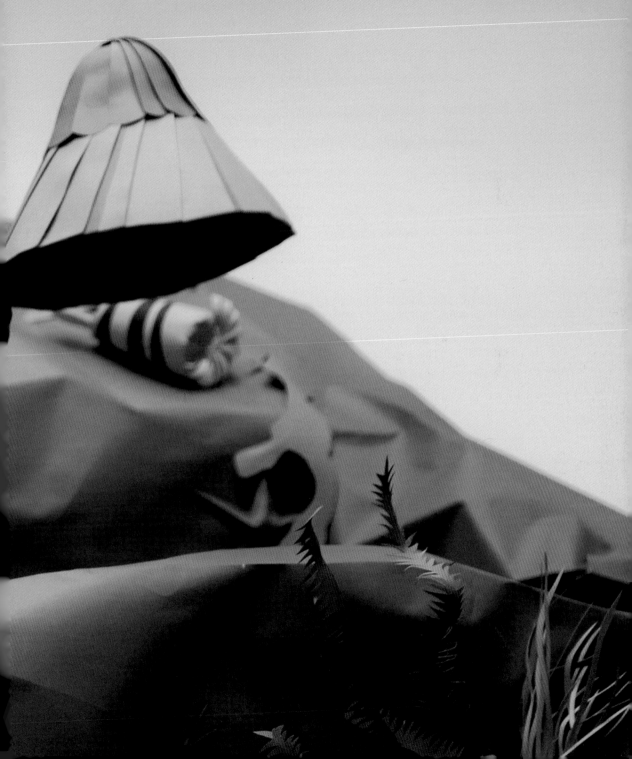

**Other limpets would swim by
and attach themselves to me**

On top of me
all of the limpets become male

We would **mate**

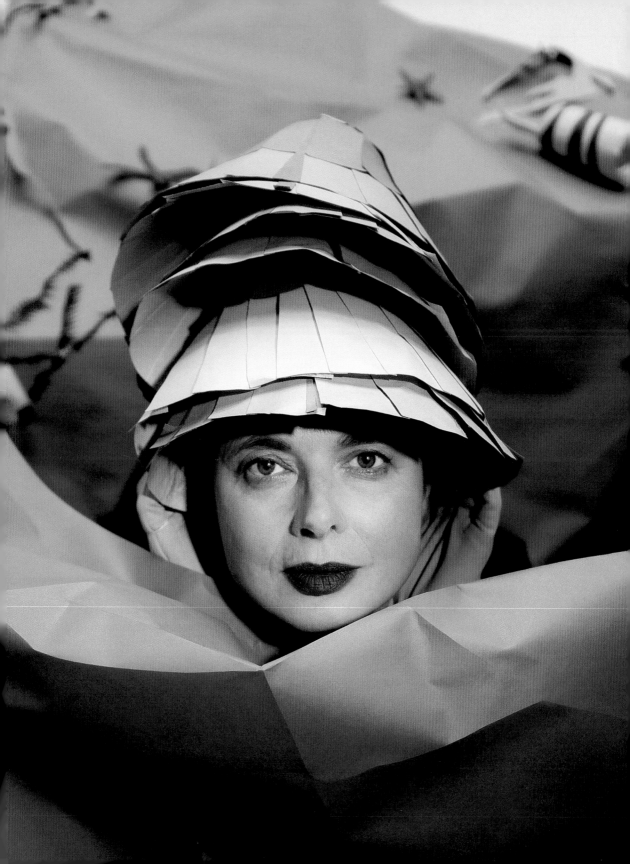

Then I die

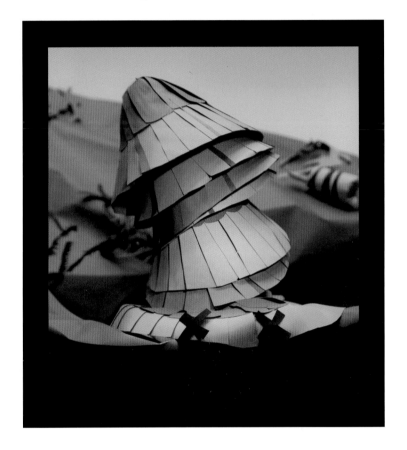

Because we all have to die

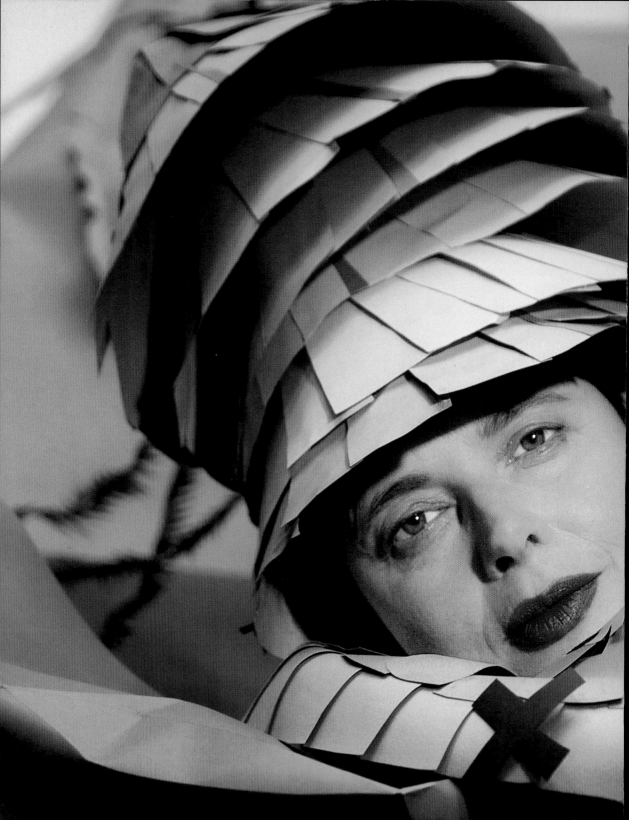

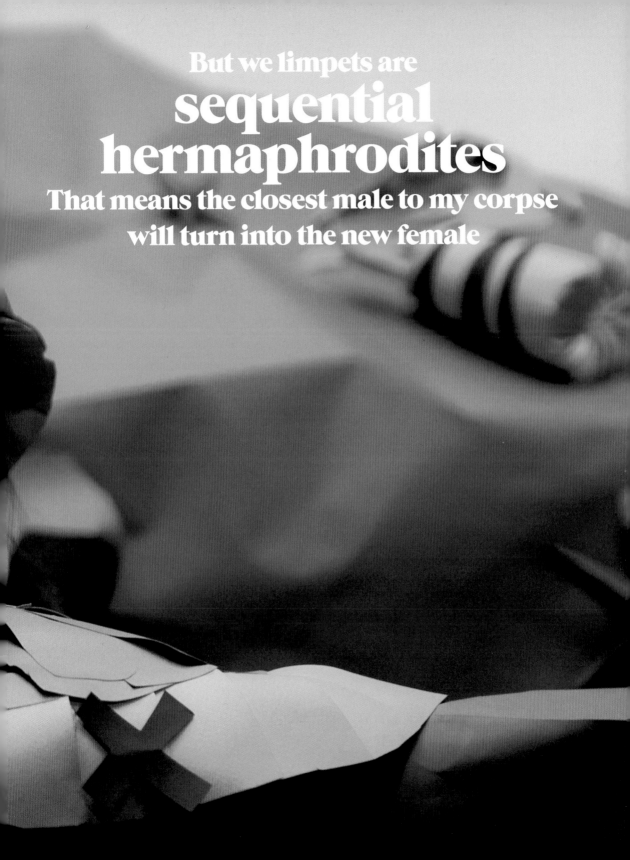

But we limpets are
sequential hermaphrodites
That means the closest male to my corpse will turn into the new female

If I were a Starfish...

I
could
reproduce
sexually or
asexually

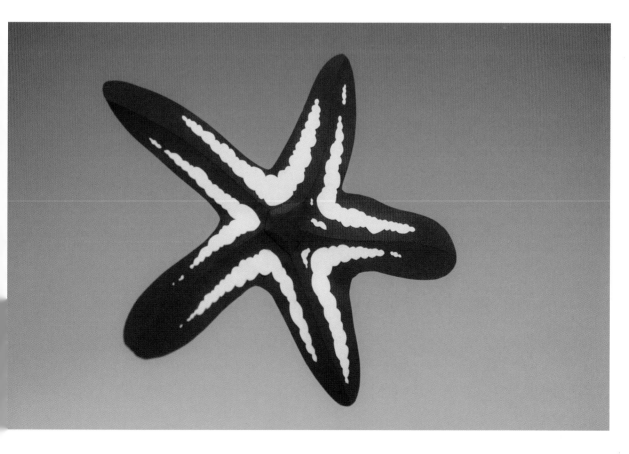

I could make
new starfish by
fragmenting
myself

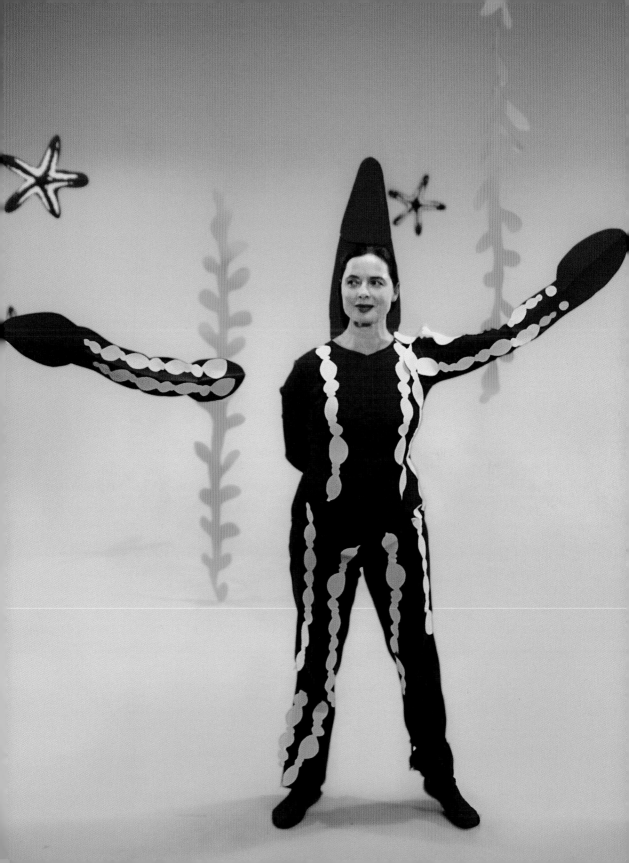

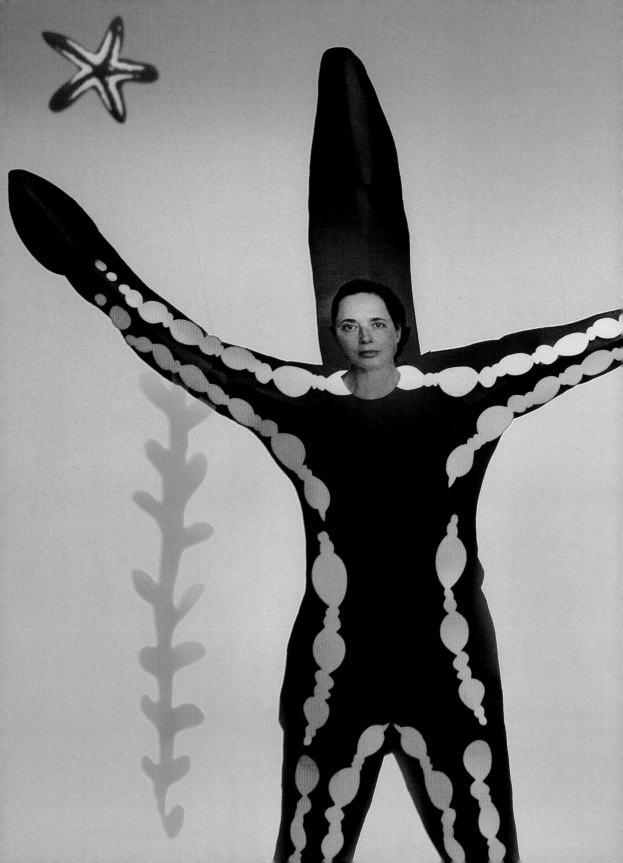

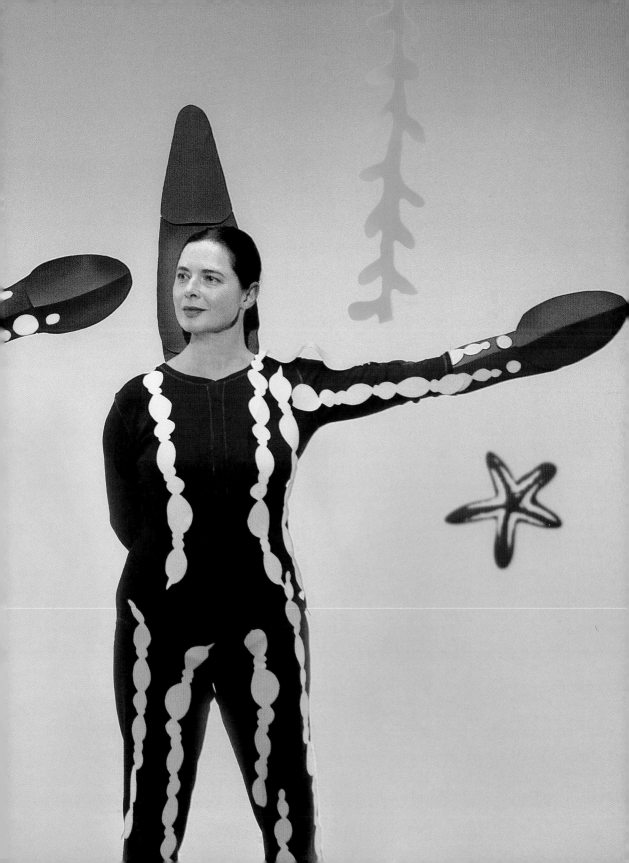

Make as many of me as I wish

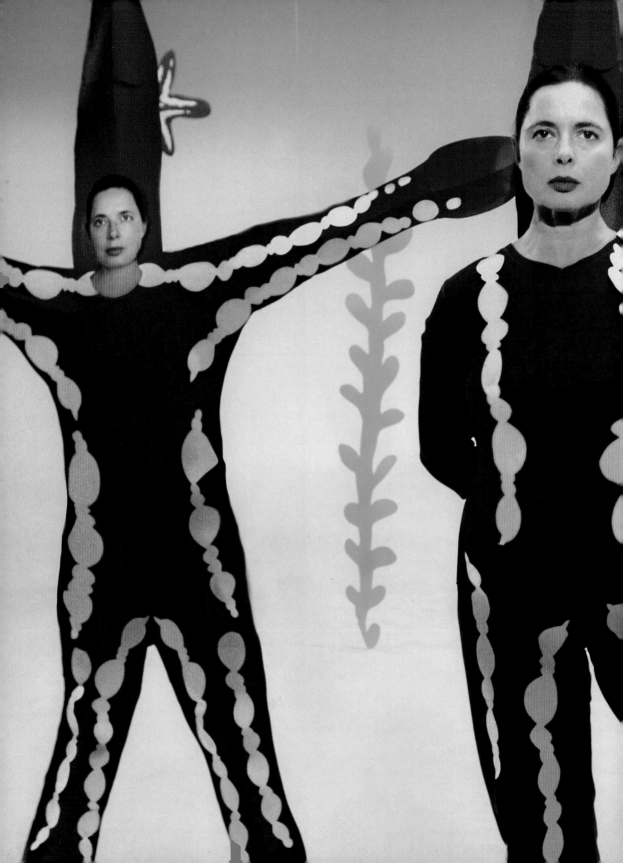

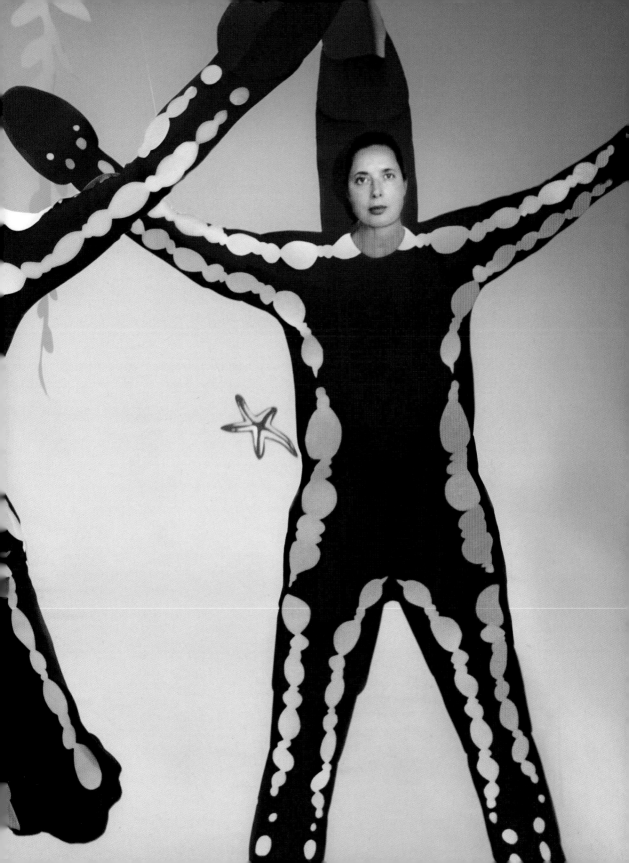

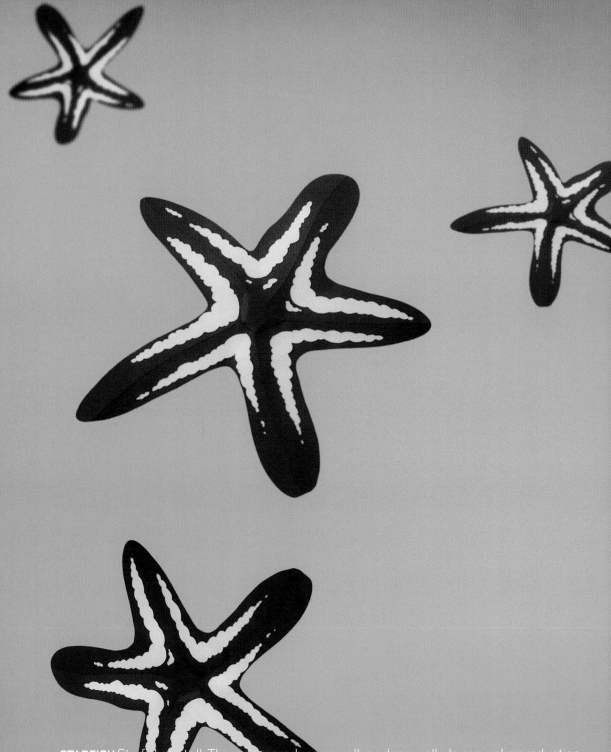

STARFISH Starfish do it all. They can reproduce sexually and asexually. In asexual reproduction a starfish fragments itself and grows its broken limbs into new starfish. In sexual reproduction a male gets very close to a female and showers her eggs with sperm, which then fertilize. Brooding females keep the eggs covering their mouths, and they cannot eat while brooding.

To reproduce I don't need a penis or a vagina

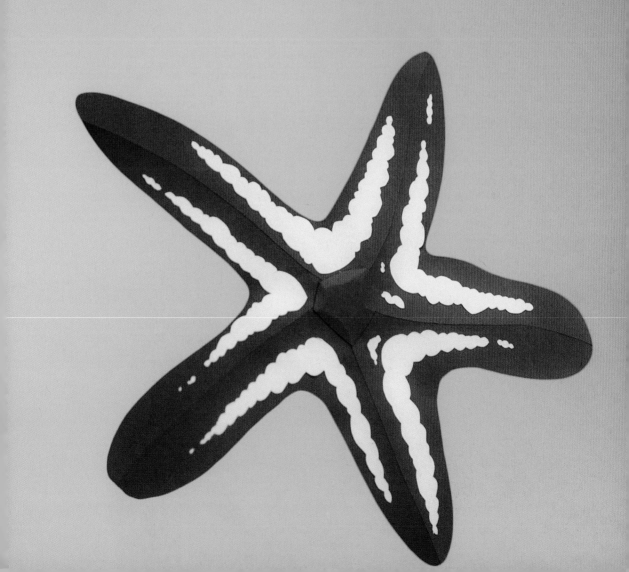

If I were an Anglerfish...

I would be so ugly
I would hide in the abyss
where there is no light

I would have a luminous lure

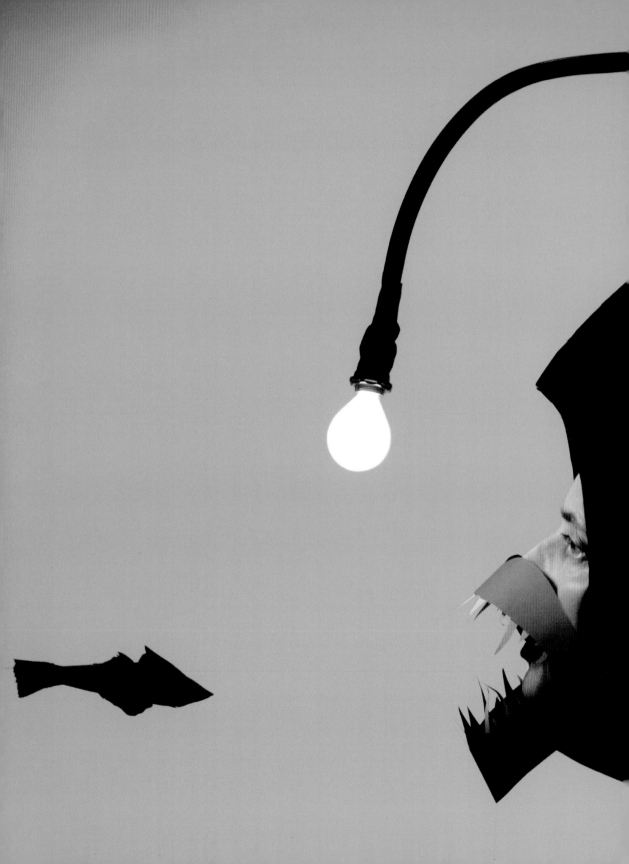

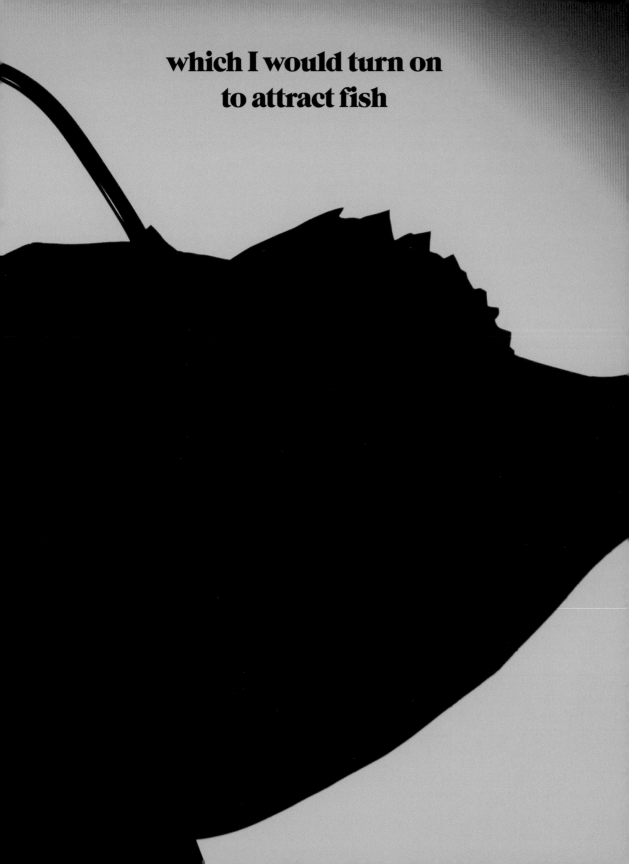

which I would turn on
to attract fish

and
suck them
into my mouth

If I were the male anglerfish
I would look
SOOOOOOOOOO
different than the female

I would have a big nose
to smell and find her in the abyss

On top of my head,
I have a kind of tooth...

...which I use to penetrate her belly and fuse myself into her body

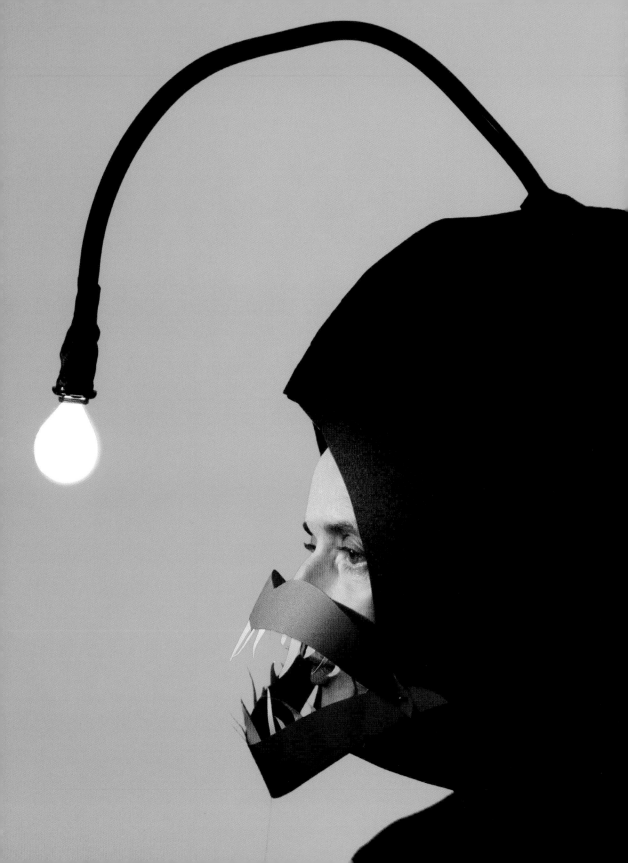

becoming her own personal sperm bank

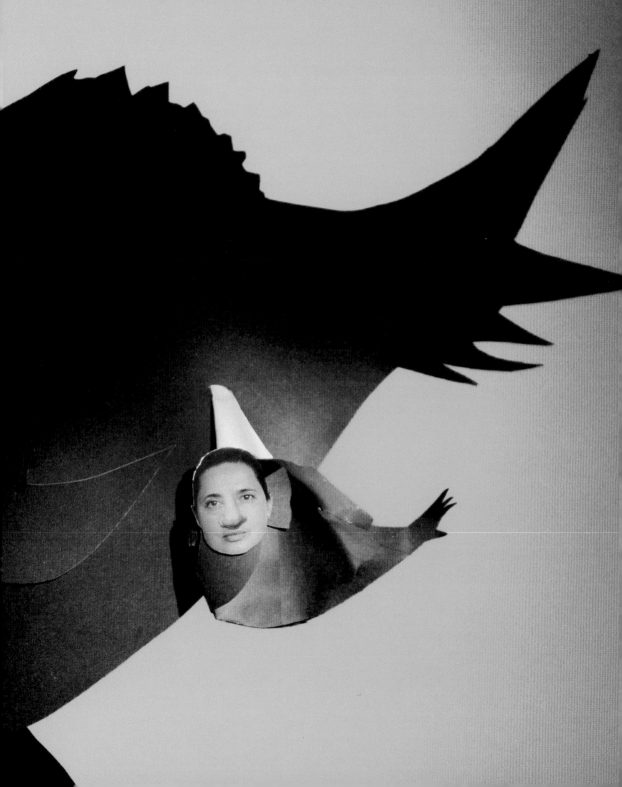

Bon Appétit!
Anchovy

Pizza Napoletana
with tomato, cheese, and anchovies

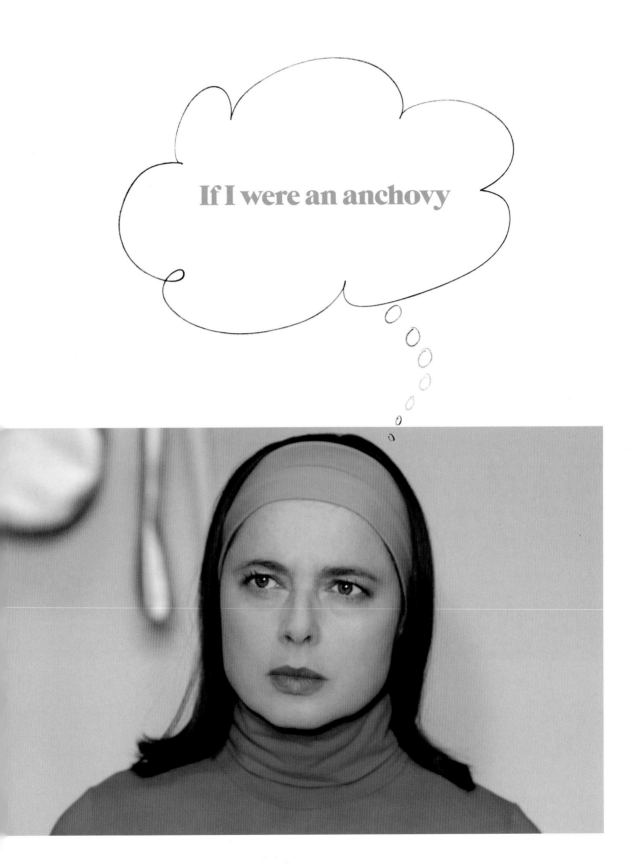

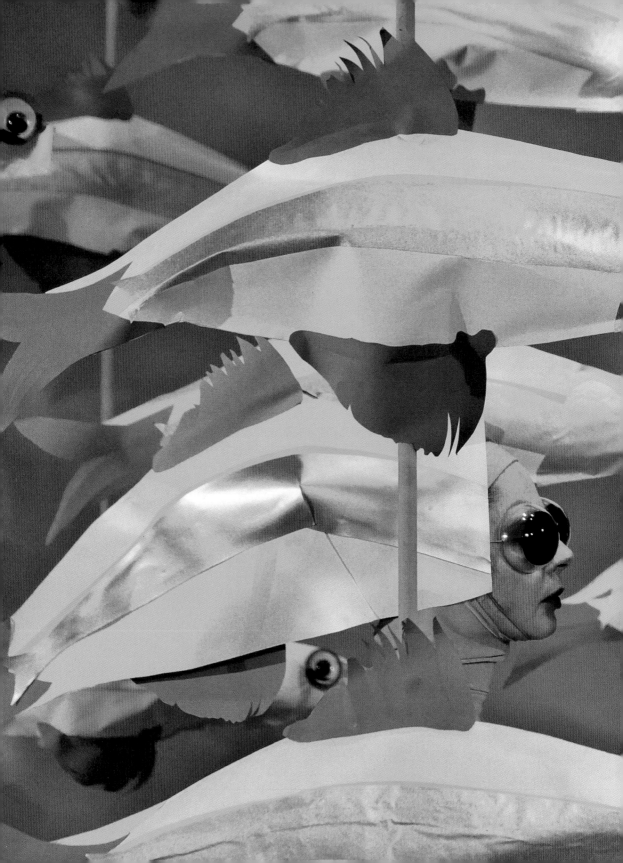

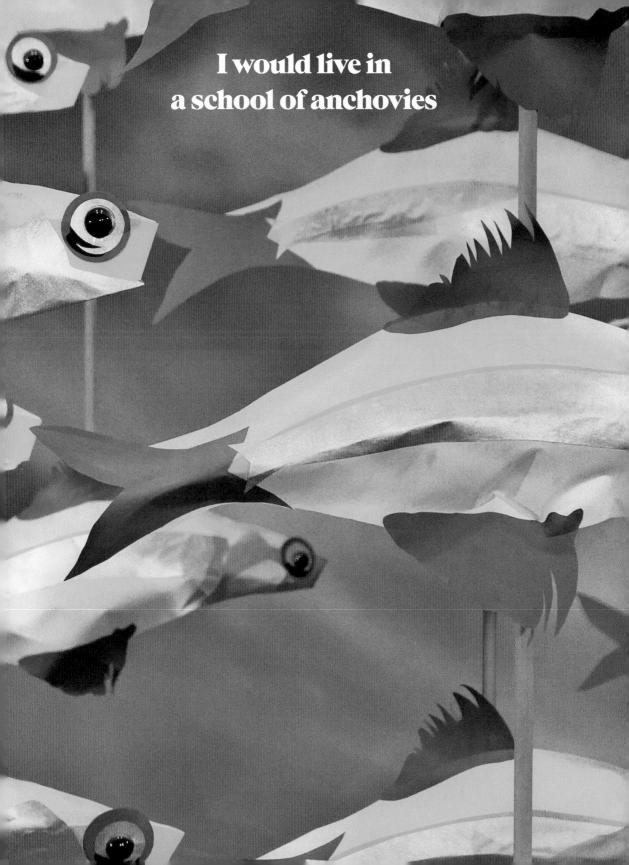

I would live in
a school of anchovies

**The most dangerous position is
at the periphery of the group where
I can be easily eaten**

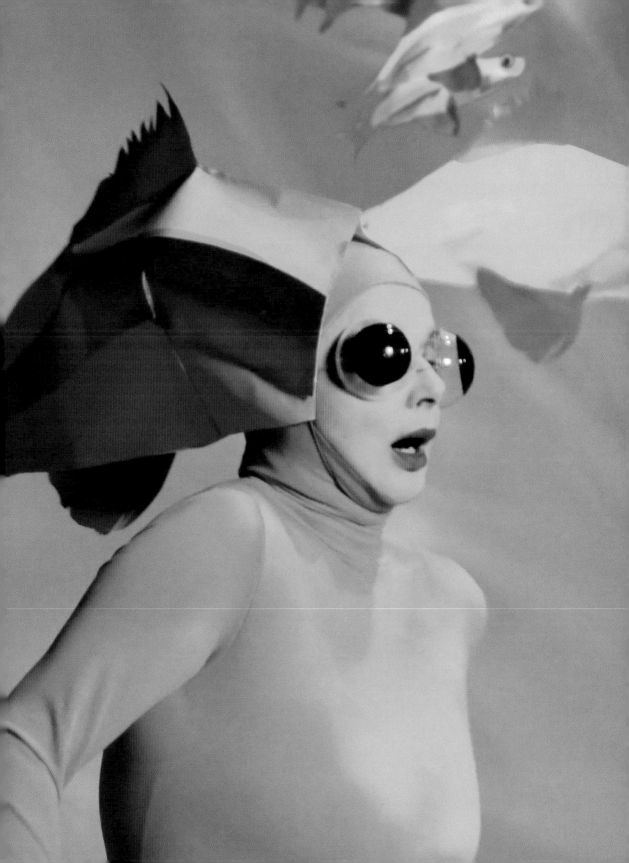

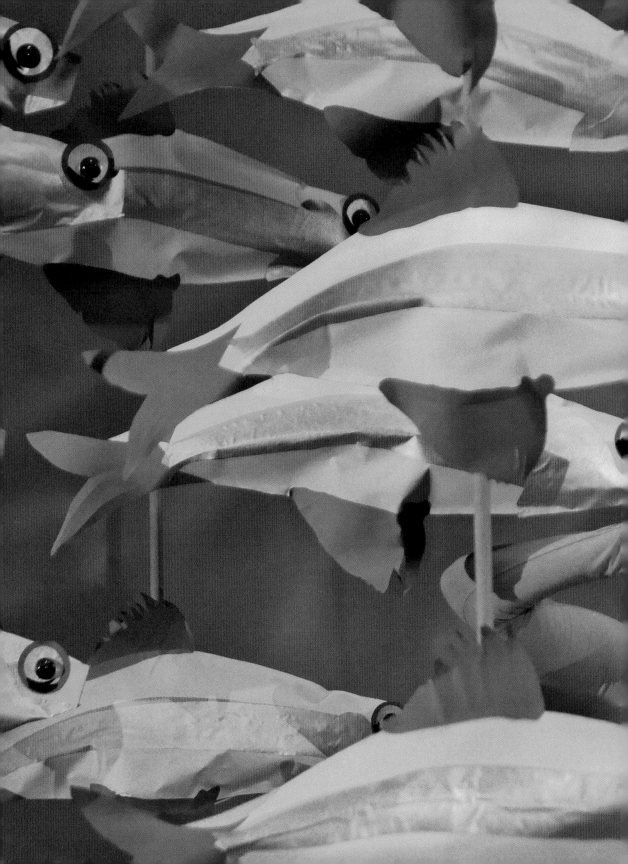

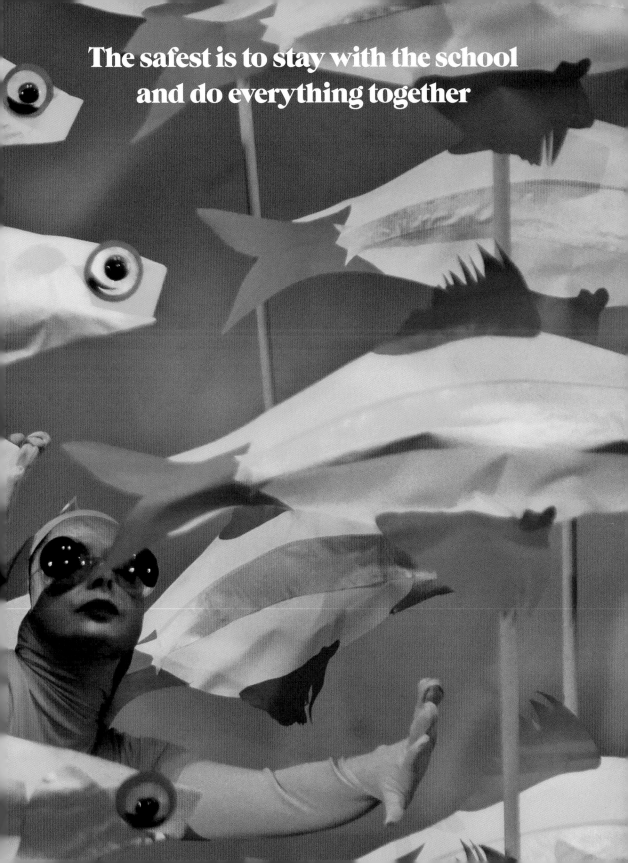

The safest is to stay with the school
and do everything together

even mating in
big orgies
called spawning

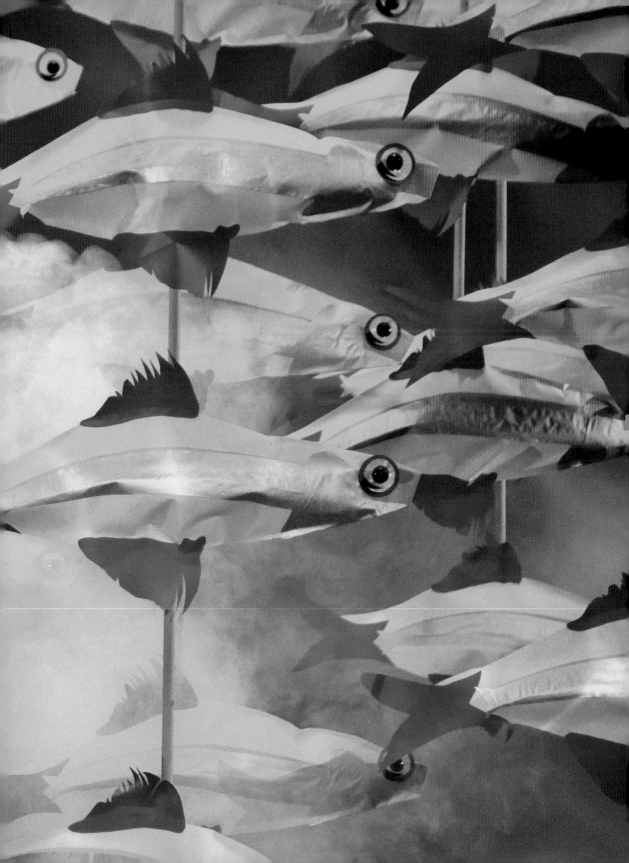

ANCHOVIES AND GROUPERS Anchovies live in big schools, but loners like the grouper only meet in order to spawn. A *spawning aggregation* is a scientific term for a large fish orgy. Groupers need to aggregate to produce the next generation, but their orgies are also very attractive to fishermen. The number of groupers at spawning orgies has decreased over time due to exploitation by fisheries that scoop up groupers while they are in the midst of reproducing. This method of fishing has compromised the survival of the grouper species.

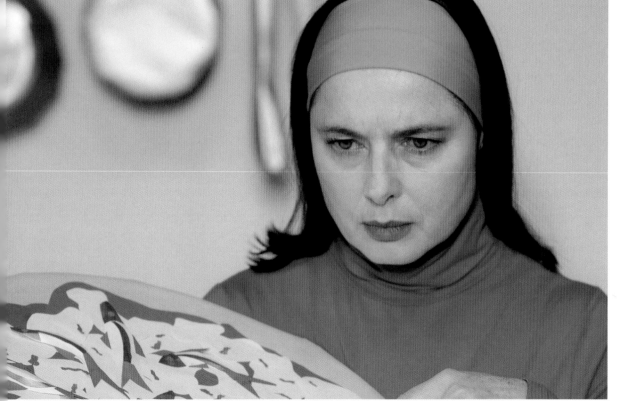

Bon Appé- tit! Squid

Yum...fried squid, calamari!

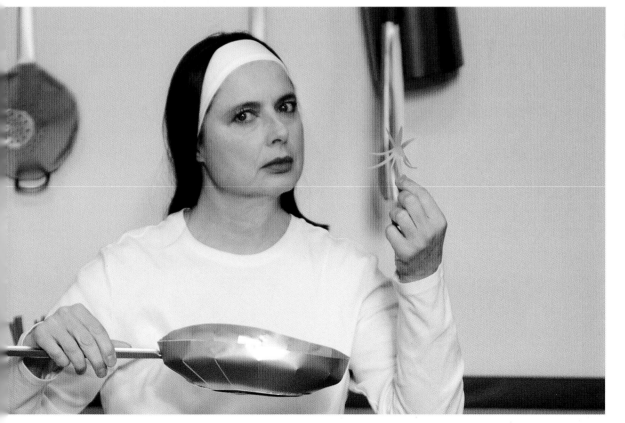

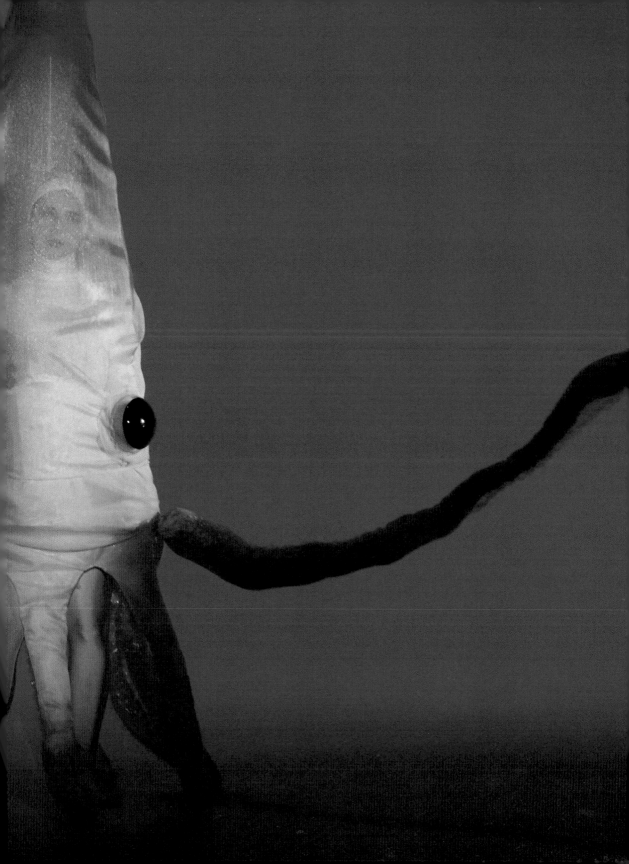

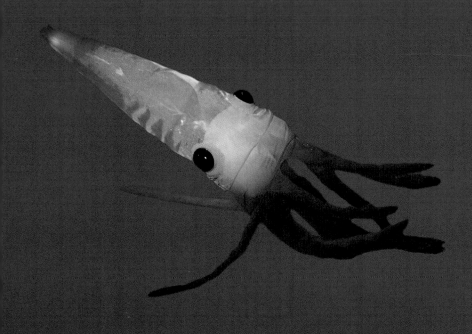

Everyone would want to **eat** me

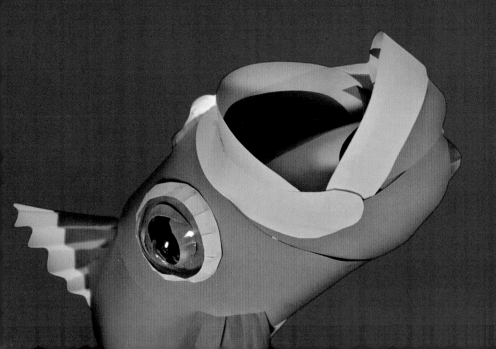

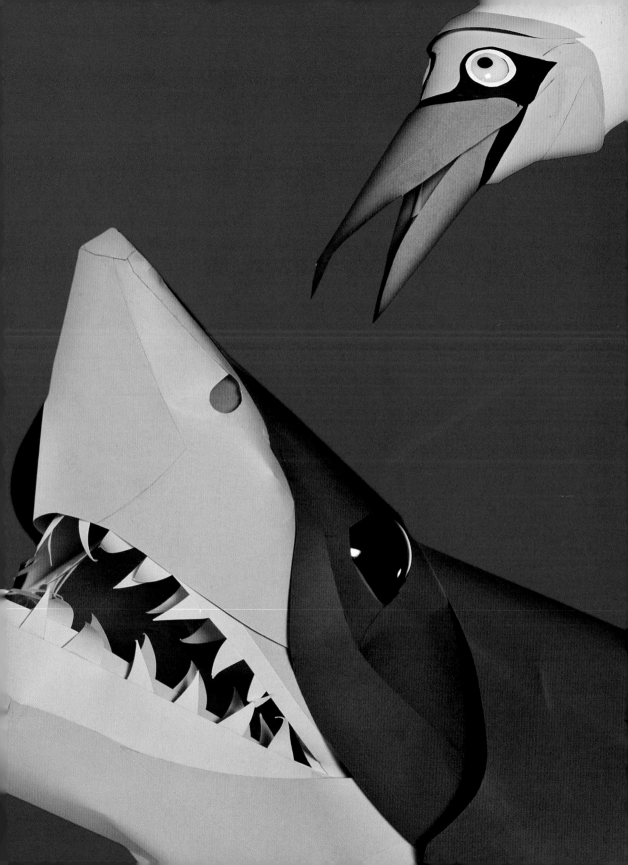

I would squirt black ink
from my anus
so that I could disappear

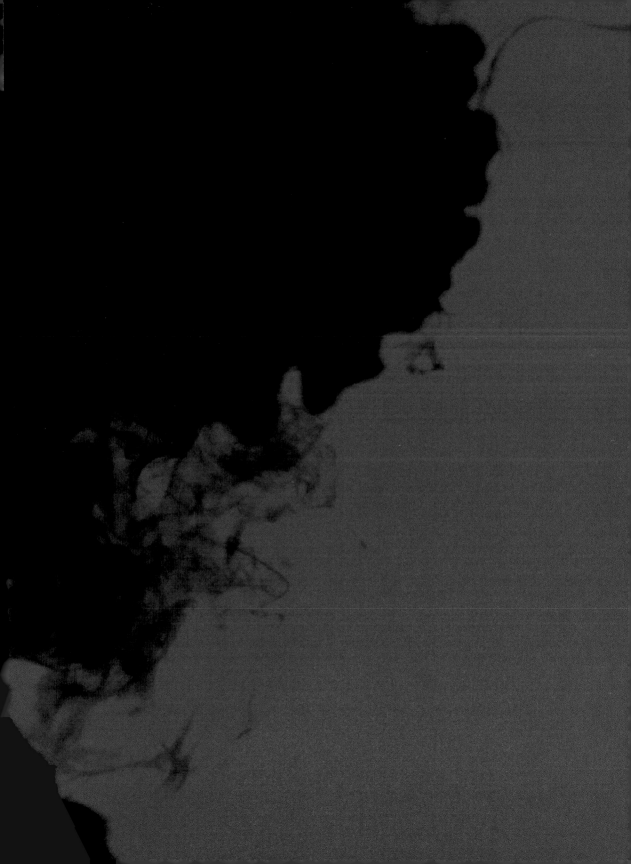

**I can communicate by
changing the color of my skin
I can say...**

I am angry!

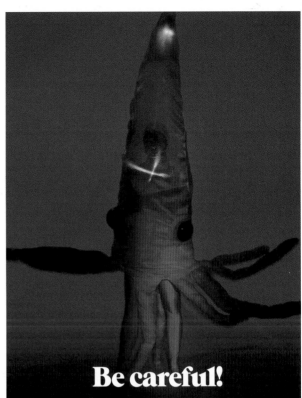

Be careful!

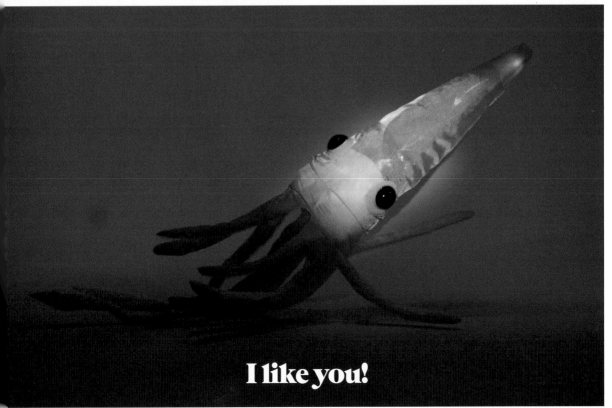

I like you!

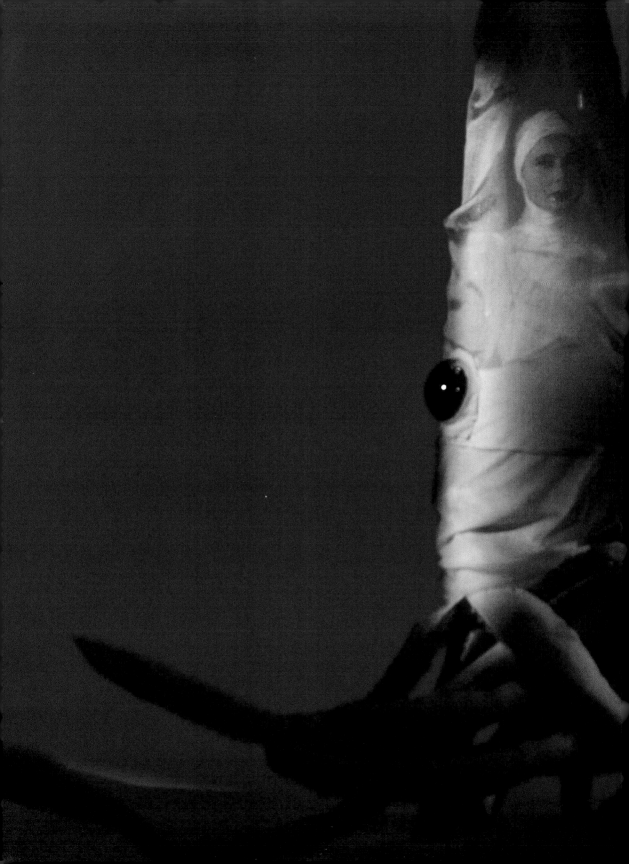

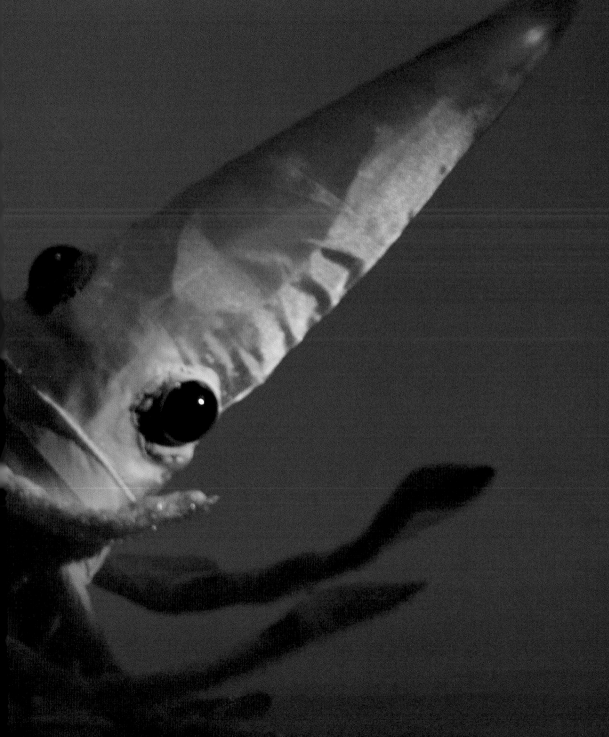

I could give the most passionate
ten-arm embrace

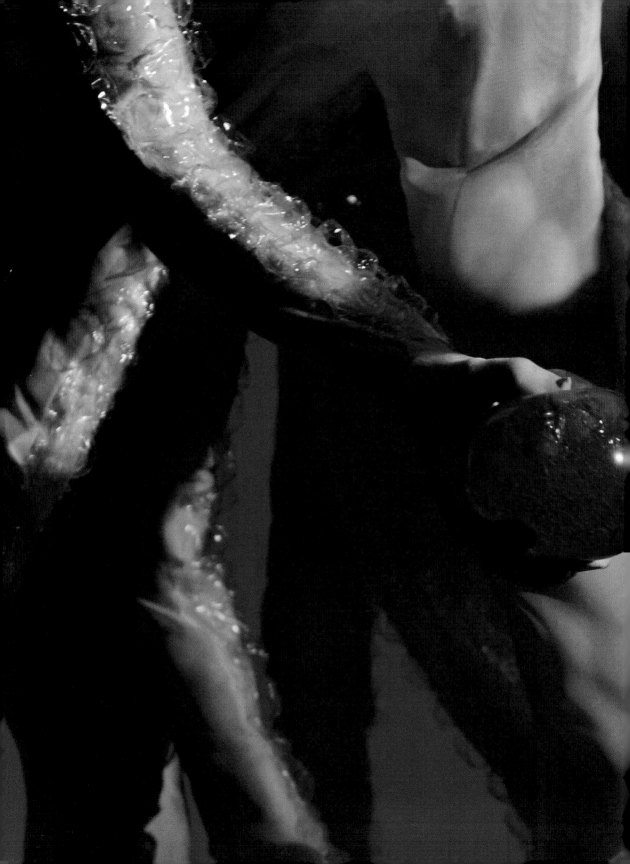

Oh no! But not all of them are arms
if you know what I mean

I would slip my spermatophore
a package of sperm
inside her spermatheca

vertically

we would

At night,

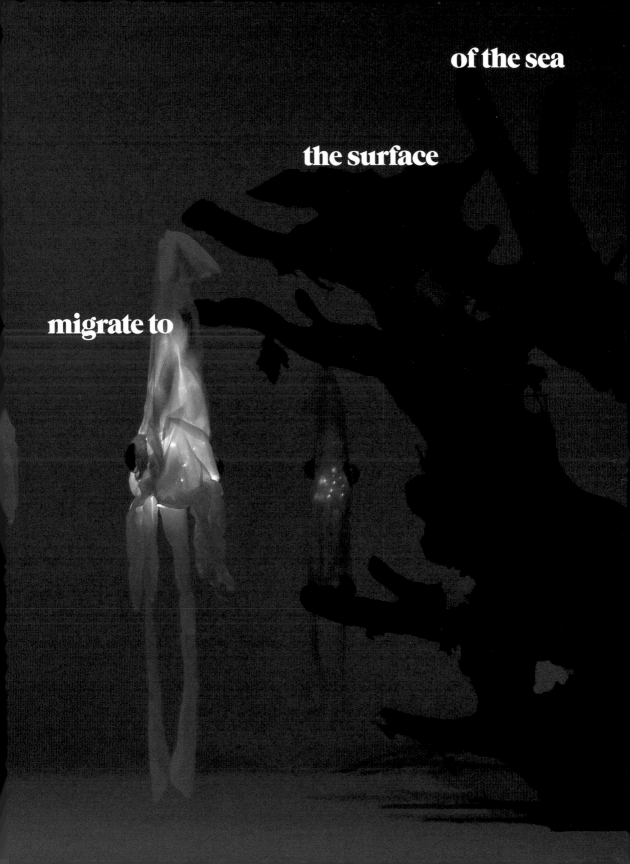

migrate to

the surface

of the sea

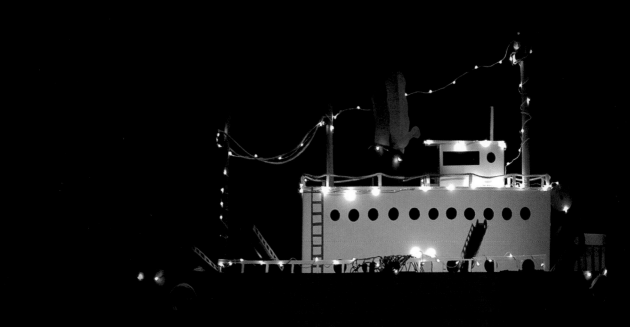

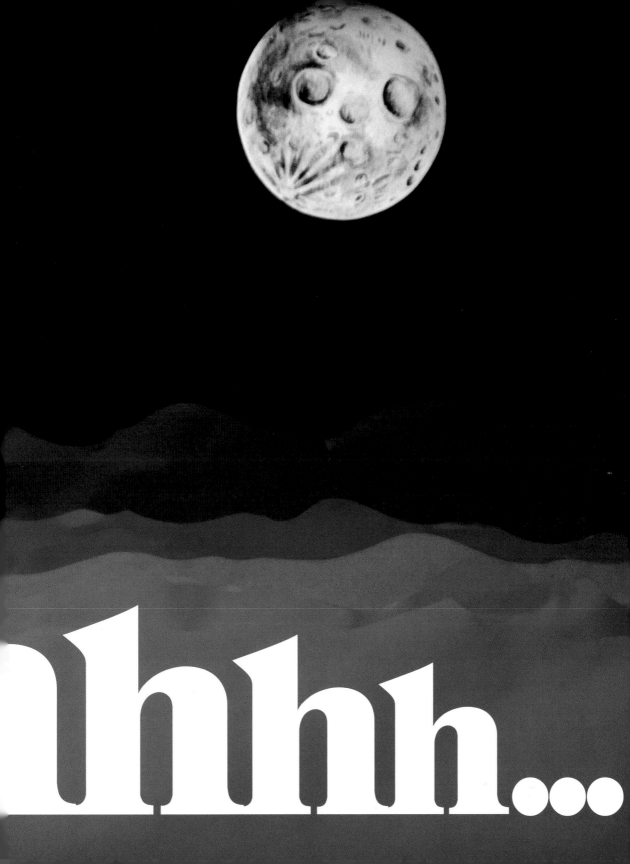

Ahhhhh...

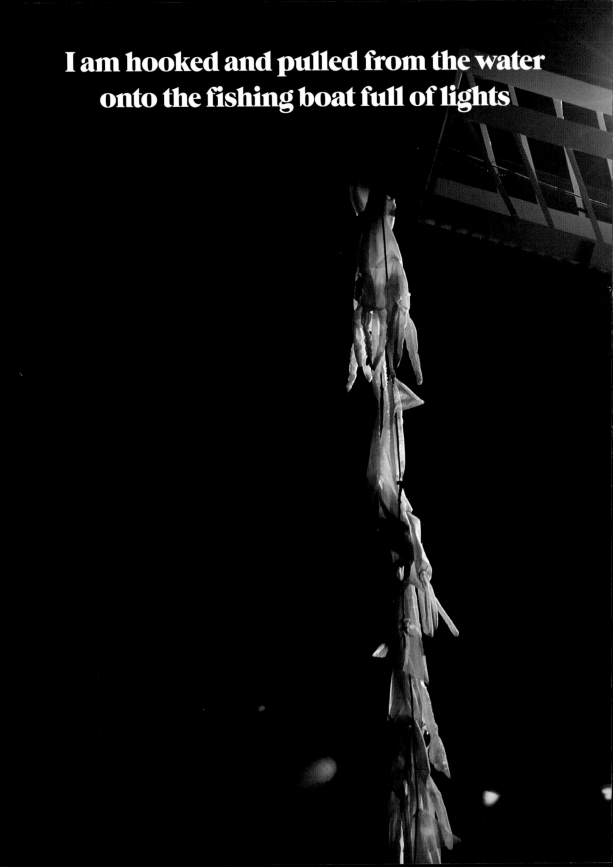

I am hooked and pulled from the water
onto the fishing boat full of lights

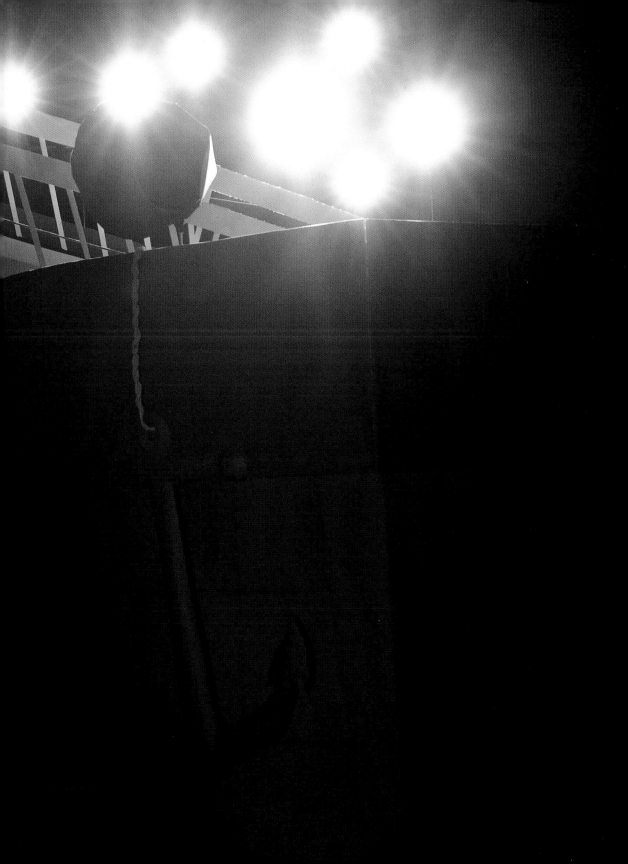

The fishing boat lights are so bright they can be seen from
outer space

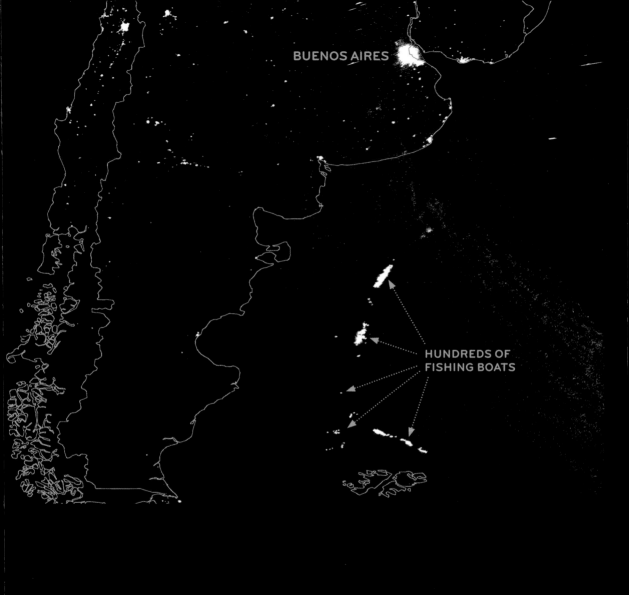

BUENOS AIRES

HUNDREDS OF FISHING BOATS

SATELLITE IMAGE OF SOUTH AMERICA AT NIGHT There are more lights from fishing boats in the ocean than from a city as big as Buenos Aires.

OVERFISHING Fisheries are wiping out ocean life, in all oceans alike. Our demand for fish consumption exceeds what the ocean can offer. The squid fishery along the continental shelf of Patagonia represents one with the highest catches in the region and may soon damage the species due to the intensity of its fishing efforts. Many fish, especially the ones we like to eat the most like hake and Chilean sea bass, have declined dramatically—70% in the last twenty years for the Argentine hake. As food declines in the ocean, dolphins, penguins, and seals, which depend on fish and squid as food sources, will all be threatened. The fishing industry will face serious challenges in this decade, but life in the oceans will face an even greater test.

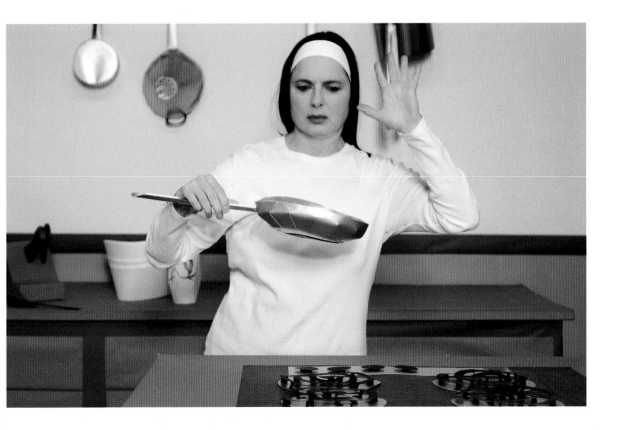

The Dangling Organ

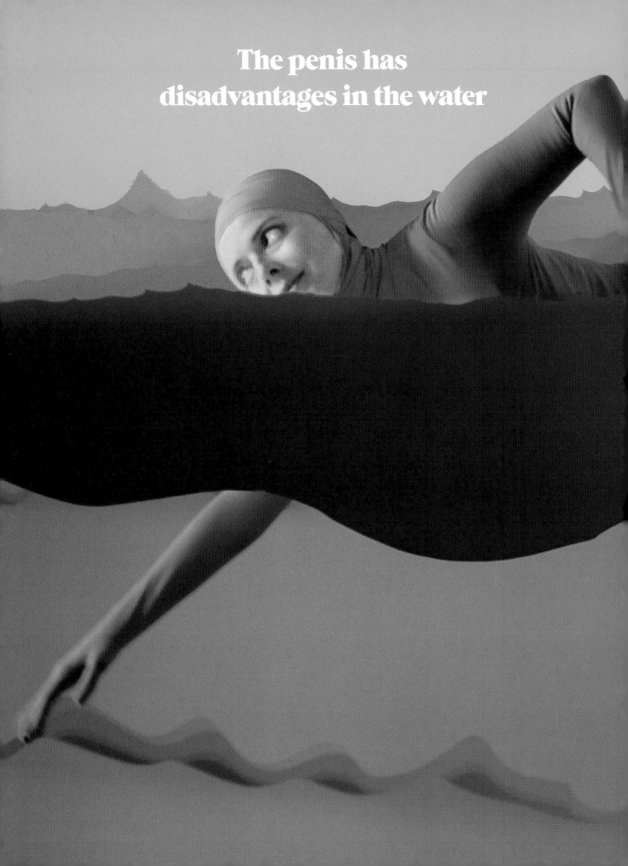

Because it produces drag

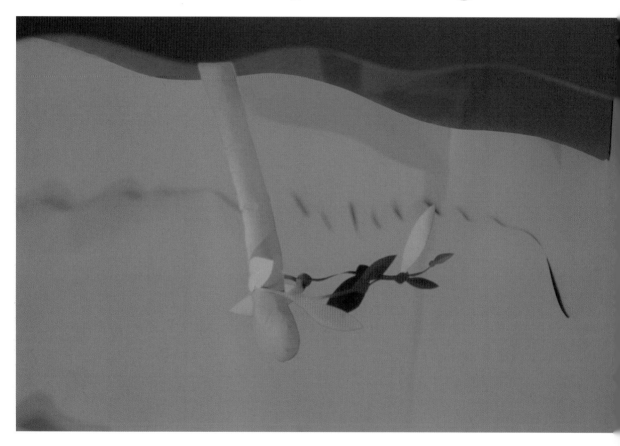

and is at risk of being snagged

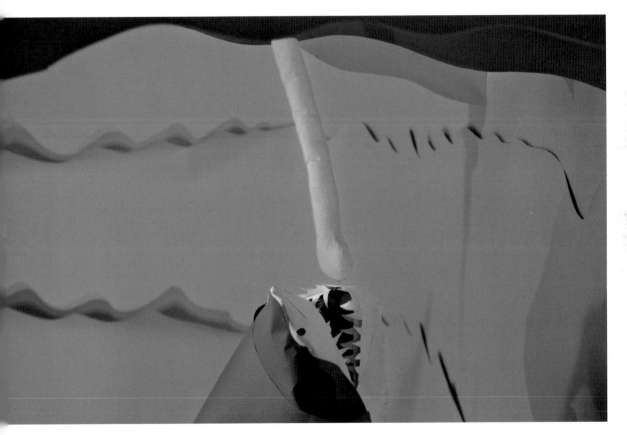

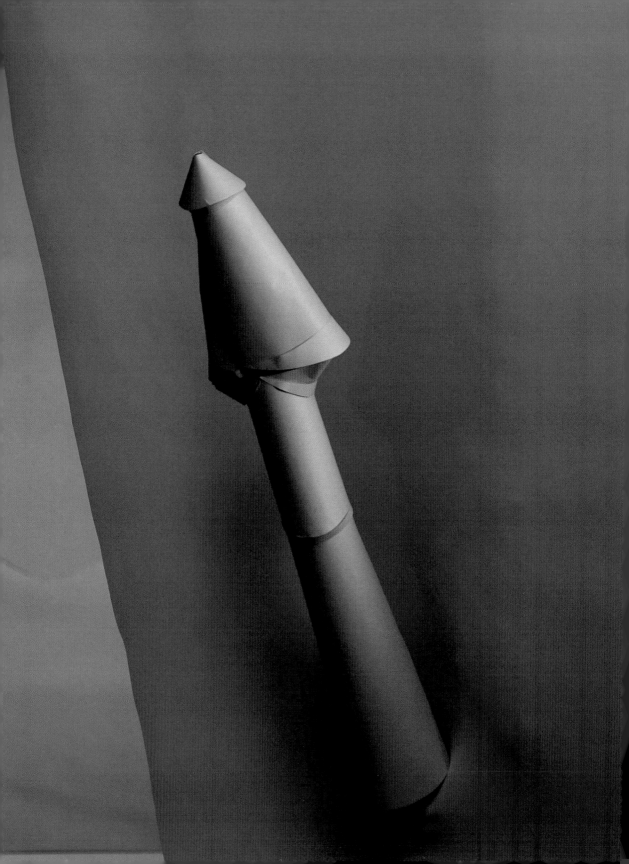

The penis should be tucked
inside the body and
when needed enlarged into
an **erection**

If I were a whale

I could have a
six-foot-long erection

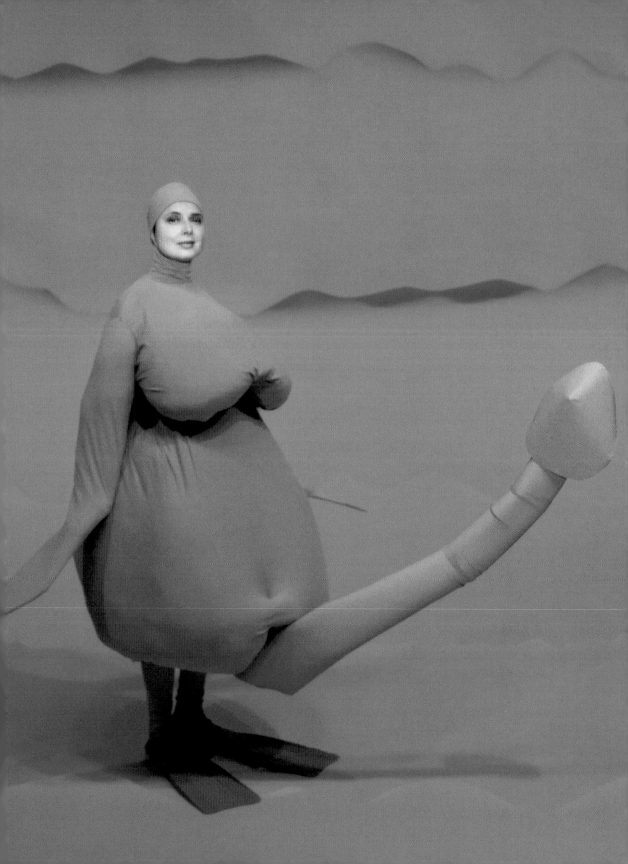

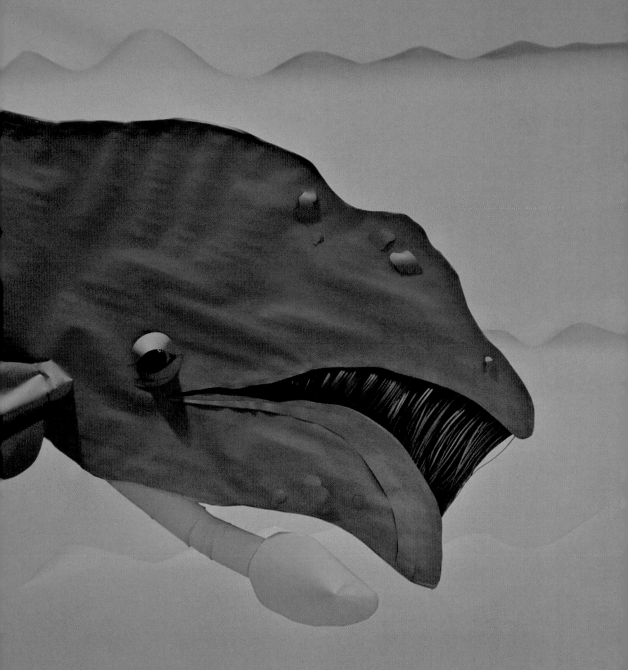

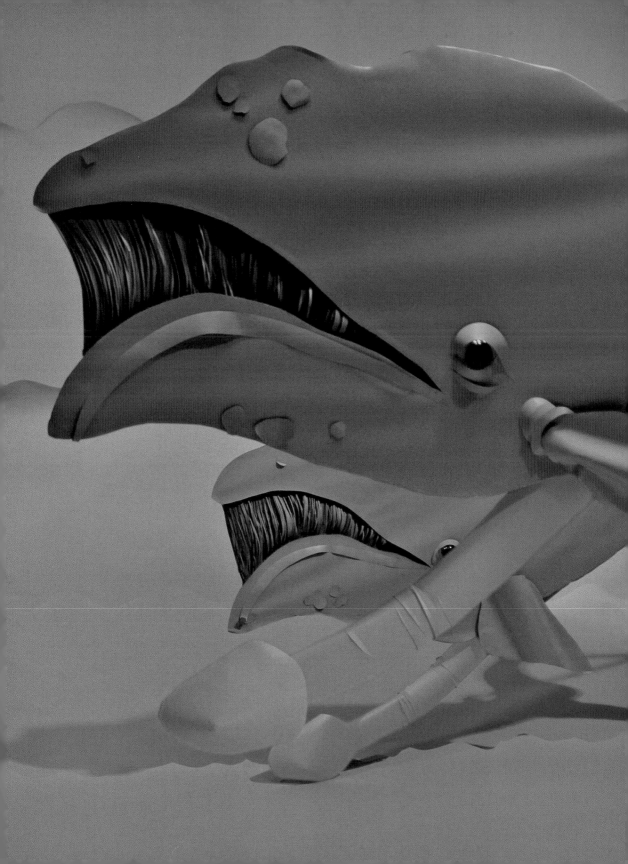

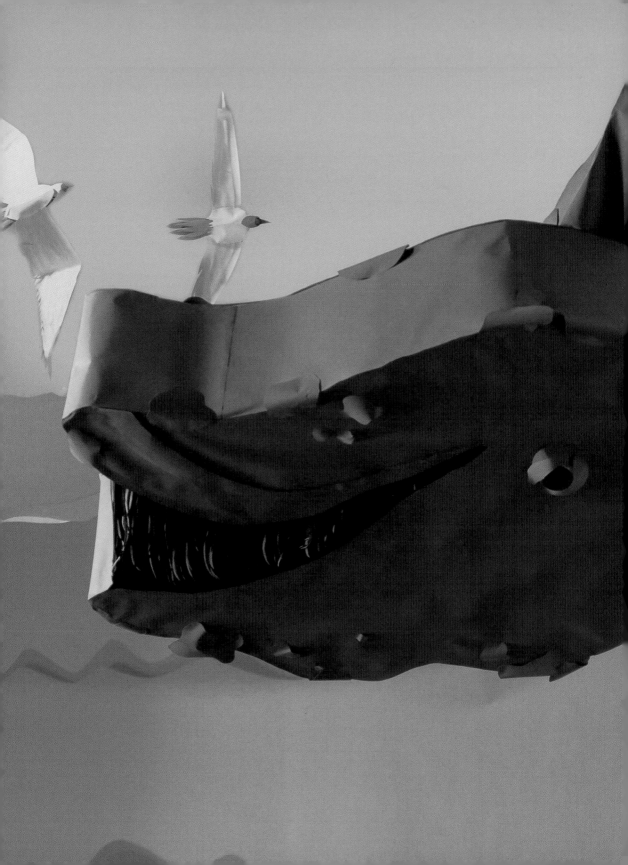

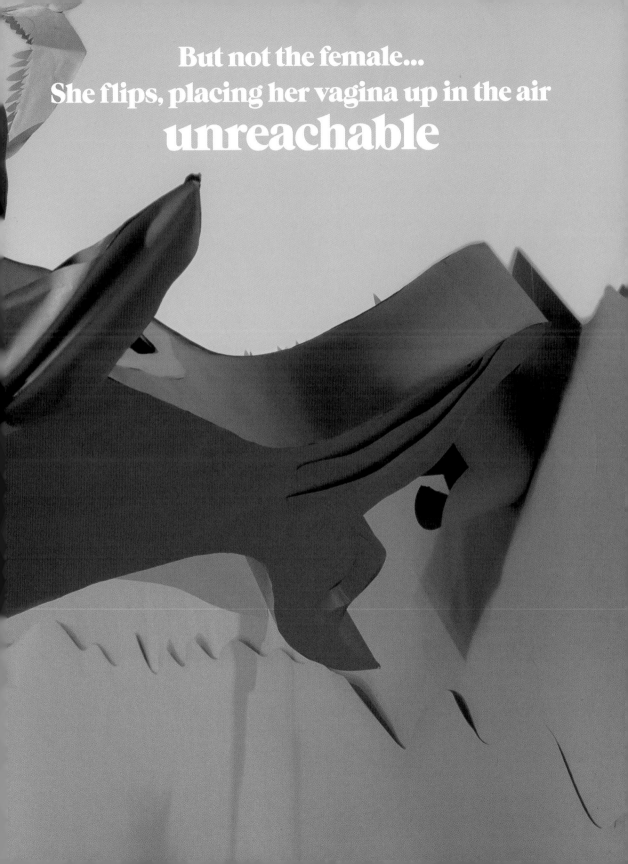

But not the female...
She flips, placing her vagina up in the air
unreachable

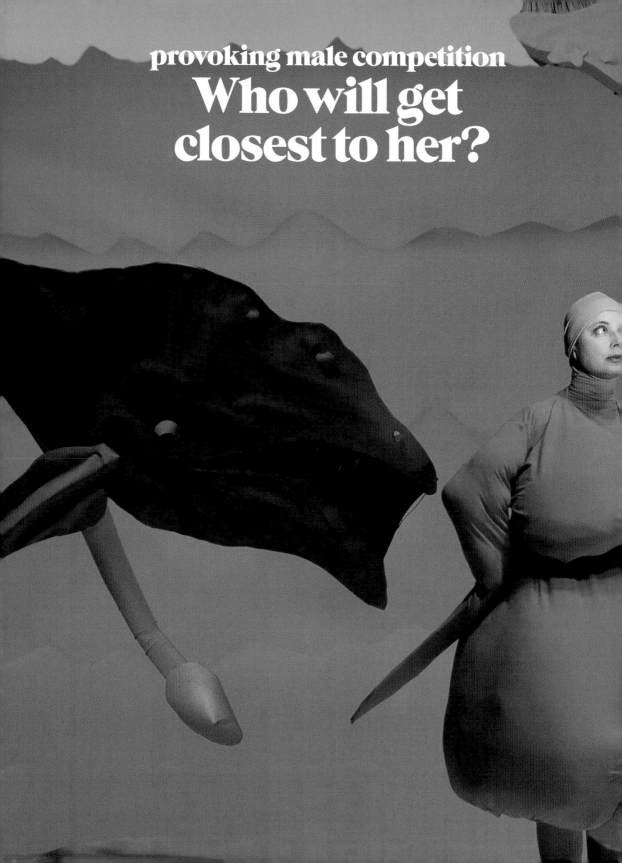

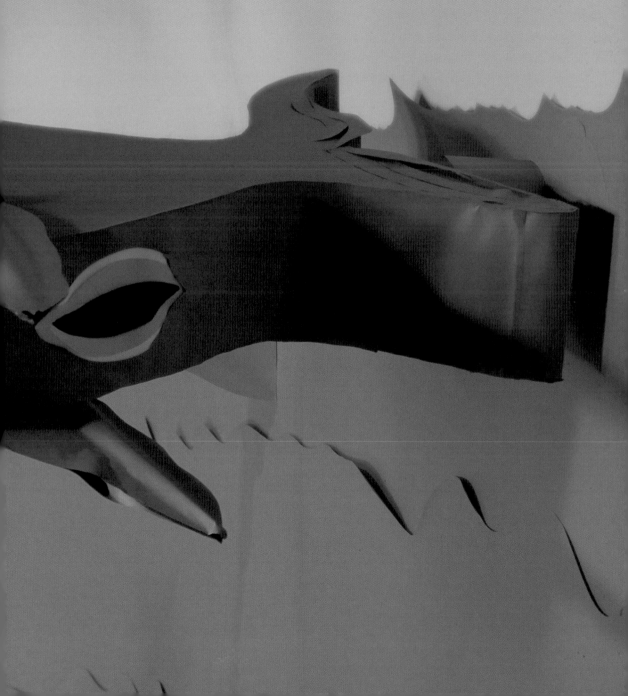

As soon as she flips again
to place her blowhole above water
to breathe...

I, the closest and strongest male, will **mate** with her

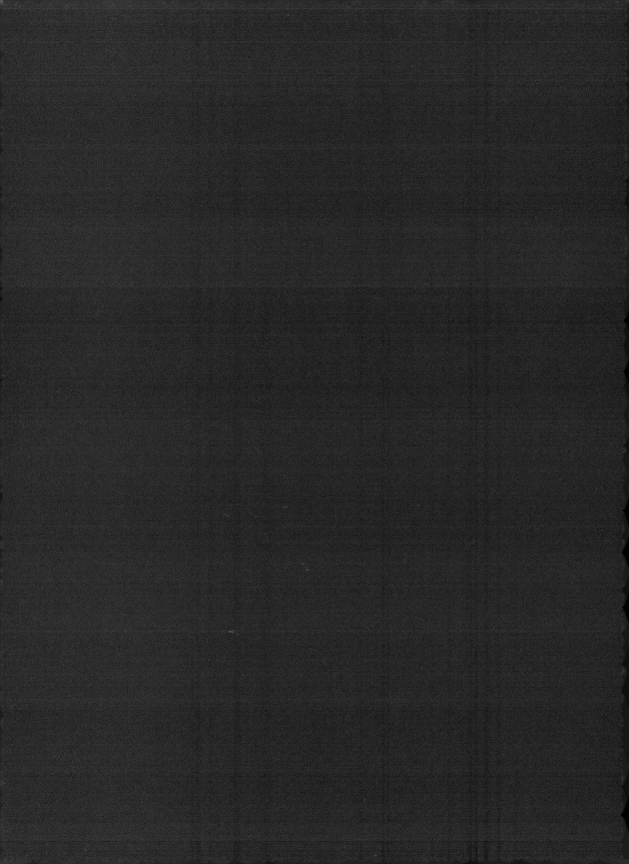

Why
Vagina

Eggs are precious.
Sperm are cheap.

Sperm come by the millions,
but not eggs.

I might have just
four hundred eggs.

If I were any female,
I would want to protect
my precious eggs.

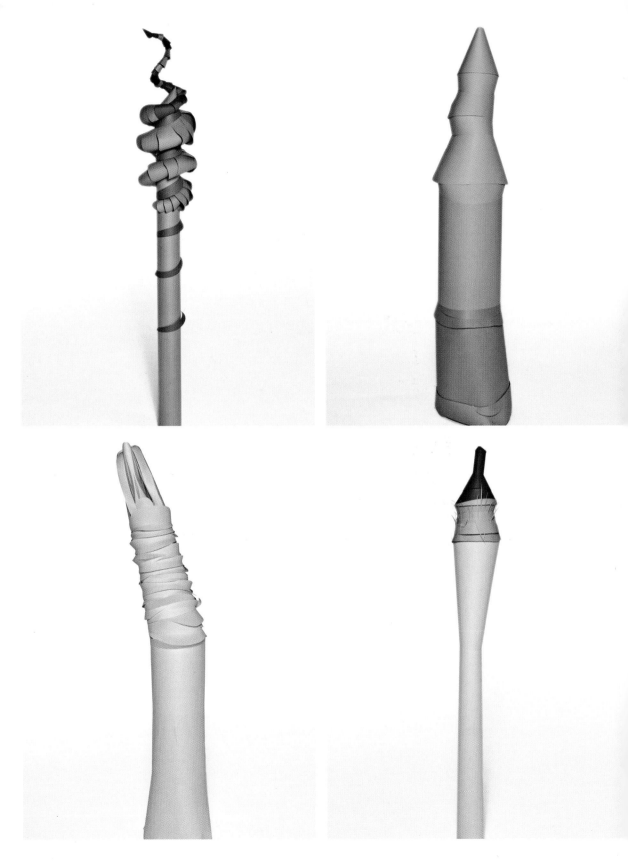

I would want to hide them
in a hole.

I would want that hole
to be in a place hard to reach,
unless I want you to reach me.

I would want the hole
to be deep because
I would want some distance
between my eggs and the males
who want to fertilize them,
which would give me a chance
to choose my male.

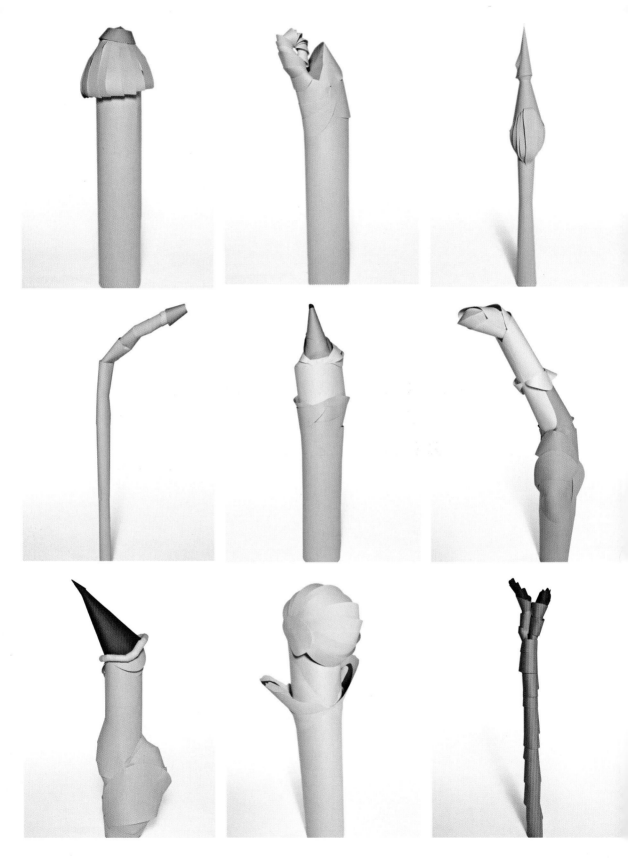

**Penises, different penises,
all trying to get
as close as possible
to my eggs.**

But I would have a tunnel,
and it would be a labyrinth.
It's intricate and it's unique.
It's species specific...
so that I am not screwed
by a bear.

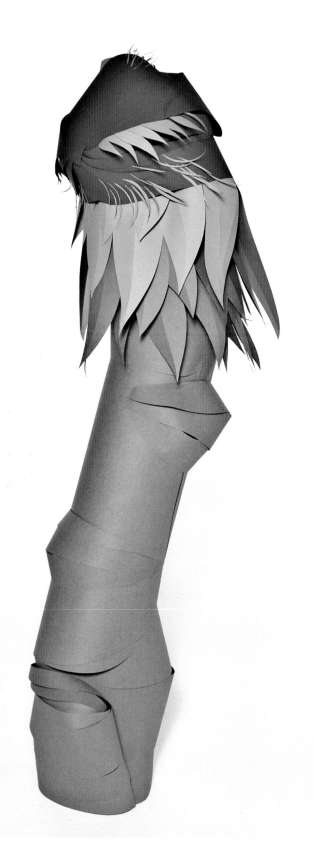

**Penises, species specific,
unique to their
respective vaginas.**

**Each a cozy fit,
like a hand in a glove.**

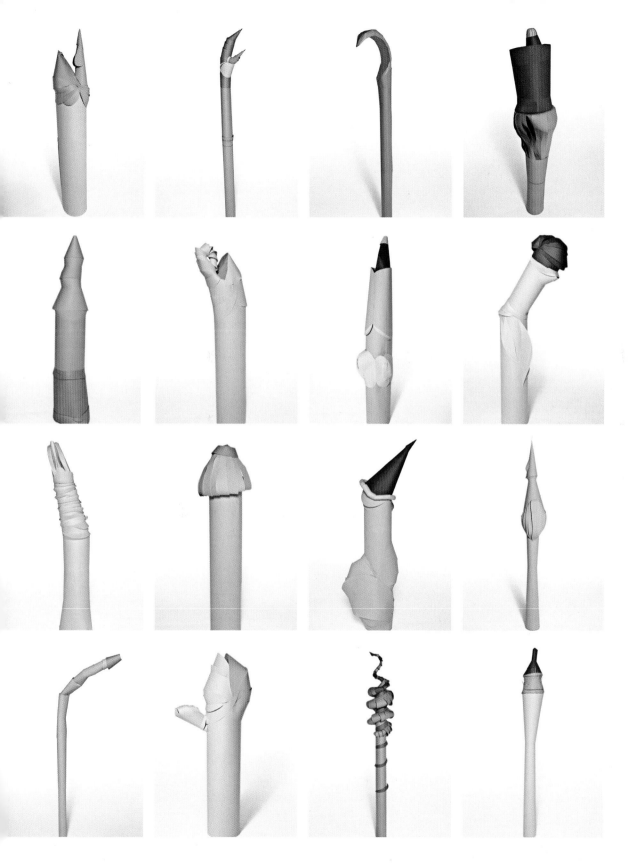

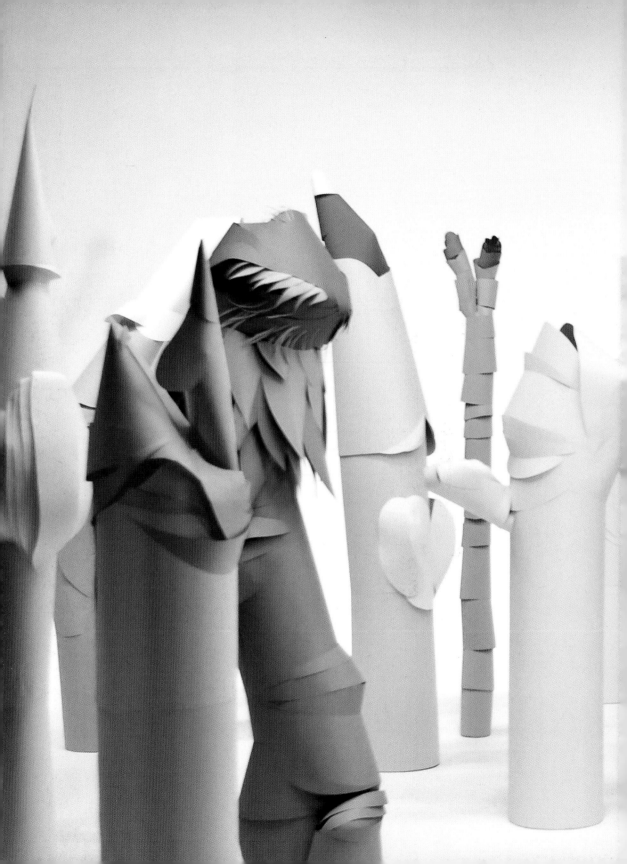

That's why I want my vagina.

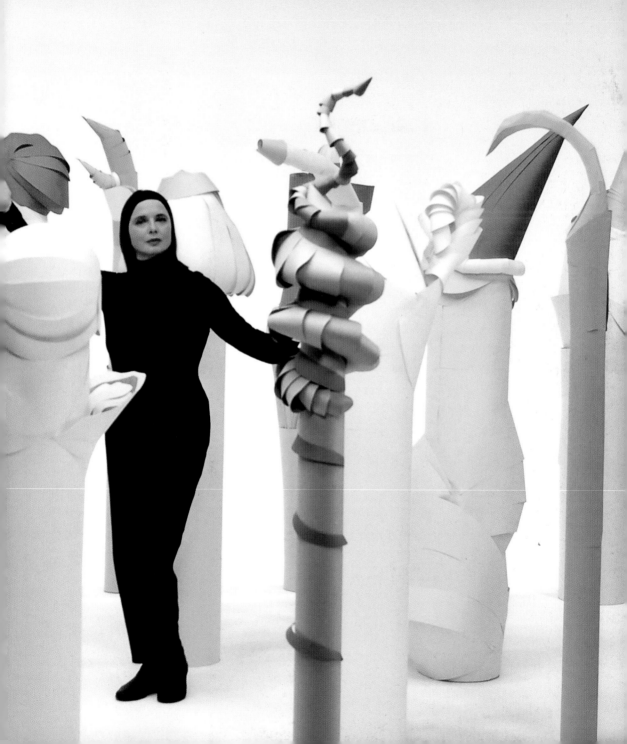